4116 3949

Printmaking on a Budget

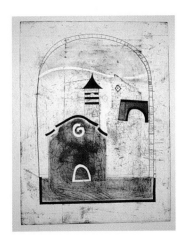

Printmaking on a Budget

MANDY BONNELL ·
STEPHEN MUMBERSON

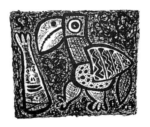

A & C BLACK ▪ LONDON

Dedication

For friends in Kenya

First published in Great Britain in 2008
A & C Black Publishers Limited
38 Soho Square
London W1D 3HB
www.acblack.com

ISBN-13: 978-07136-7349-4

Copyright © 2008 Mandy Bonnell and
Stephen Mumberson

All images: Copyright © the individual artists

CIP Catalogue records for this book are available
from the British Library and the U.S. Library of
Congress.

Mandy Bonnell and Stephen Mumberson have
asserted their right under the Copyright, Design
and Patents Act, 1988, to be identified as the
authors of this work.

Typeset in 10.5 on 12.5pt Minion

Book design: Susan McIntyre
Cover design: Sutchinda Rangsi Thompson
Copyeditor: Julian Beecroft
Managing Editor: Susan Kelly

Printed and bound in China

A & C Black uses paper produced with elemental
chlorine-free pulp, harvested from managed
sustainable forests.

Publisher's note: Printmaking can sometimes
involve the use of dangerous substances and
sharp tools. Always follow the manufacturer's
instructions and store chemicals and inks
(clearly labelled) out of the reach of children.
All information herein is believed to be accurate;
however, neither the author nor the publisher can
accept any legal liability for errors or omissions.

FRONTISPIECE: Kathleen Mullaniff, *A Stranger to this Place*, silkscreen on canvas on wood panel,
152 × 122 cm (5 × 4 ft), 2002

CONTENTS

Acknowledgements

Thank you to all the artists who have generously contributed to this book.

We would also like to thank the following: Bath Spa University, Julian Beecroft, Michael Carlo, Emma Douglas, Anne-Marie Foster, David Harding, Peterson Kamwathi, Susan Kelly, Libby Lloyd, Timo Lehtonen, Susan McIntyre, James Mbuthia, Simon Muriithi, James Muriuki, Middlesex University, John Phillips, Jane Stobart, Martin Thomas, Joni Waite, Wildebeest Workshops, and A&C Black for help and support throughout the writing of this book.

INTRODUCTION

The aim of this book is to look at printmaking in a contemporary context for artists on limited means and resources, where finding the tools, materials and equipment needed to produce an original, experimental fine-art print seems on the surface to be a difficult task. The emphasis is on individual exploration and investigation through lots of different printmaking techniques and procedures.

Working in response to a concept with a view to producing a single original printed image, as well as traditional editioning, opens up a lot of possibilities to try. Combining printmaking processes can be both effective and creative and very straightforward to do, and does not have to be expensive.

A print is a transfer of marks and ink from one surface to another either using conventional techniques such as relief, intaglio, lithography, screen-printing or digital printing. Combining two or more of these methods offers further possibilities. All are unique in practice.

Artist James Mbuthia produces very effective and elegant woodcuts using the colour-reduction technique. Traditionally, the lightest colour is printed first and the darkest colour last. Mbuthia's simple twist is to print the darkest colour first and the lightest colour last. This straightforward alteration of the traditional approach gives his images a fresh and vibrant individuality.

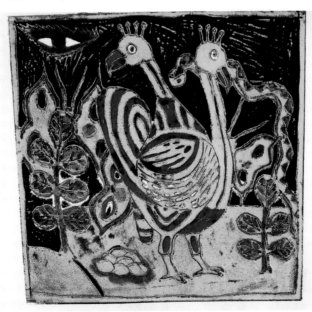

James Mbuthia, *Untitled*, colour reduction woodcut, MDF, 25 x 25cm (10 x 10 in.)

Alf Dunn *A Man*, lithography and silkscreen 56 × 76cm (22¼ × 30 in.)

RIGHT
Oona Grimes, *Spirits of Salts 11 and 12*, etching and letraset, 120 × 186 cm (47¾ × 72¾ in.)

Timo Lehtonen, *Lafroda VII*, Relief print, diffused ink, graphite, 57 × 76 cm (22¾ × 30 in.)

Maintain an open-minded approach to trying out different tools and materials; the possibilities include both the conventional and the more unusual. An element of improvisation, imagination and spontaneity, as well as trial and error, is required. There is a lot of scope within each process, with helpful handy hints and recipes to try. A whole chapter is concerned with paper and its use and treatment within printmaking.

Purchasing tools, equipment and materials can be very expensive, so finding and sourcing alternative tools and materials is essential. Throughout this book there is plenty of information on printmaking with and without a press, printing using found materials, on different approaches to print using packaging and simple paper-engineering techniques to produce three-dimensional, sculptural, printed images, sketchbooks and portfolios, and on uncomplicated, affordable approaches to making artists' books.

Terry Poh, *He Ran and Ran*, relief print using rope pressed onto oil based surface, 53 × 38cm (21 × 15 in.), monoprint

Producing creative, professional prints does not necessarily mean spending a lot of money; it is about successfully executing a good idea that works within itself. This can be achieved on a kitchen table, in a garden shed or in a small working area within an existing studio space, as well as by setting up an affordable printmaking workshop.

Our objective throughout has been to produce a user-friendly, helpful book offering information, solutions and alternative ideas to try to resolve the kinds of difficulties that artists who use printmaking can often be faced with. We hope the result is an interesting read that can be dipped into for help and information.

Safety

Always keep for health and safety concerns uppermost in your mind when printmaking. Keep your use of solvents to a minimum, and store them in a metal bin with a lid. The same goes for used rags; paper towels are less hazardous to health and more environmentally friendly, and can be thrown

Fernando Feijoo, *The Early Hours of the Morning*, lino cut, 80 × 60 cm (31½ × 23½ in.)

away. Used rags can cause spontaneous combustion, so take care not to allow a pile of them to accumulate.

Do not use chemicals that need fume cabinets, unless you can afford to have one installed. In that regard, with etching processes, use ferric chloride and acetic acid. Store these chemicals separately in a cool, dark cupboard or an outside shed. Chemicals for lithography, such as Erasol and Prepasol, need to be stored in the same way. In any case, work in a well-ventilated room.

Mathew Meadows, *A Short Walk in Harrow Road*, relief transfer, 65 × 150 cm (25½ × 59 in.)

Sheila Sloss, *Watching – Dancing Dresses 11*, lithography, collagraph, screen print, monoprint, (series) 55 × 45cm (22 × 17¾ in.)

Vegetable oil dissolves printing ink cheaply and safely, and is recommended for cleaning rollers and surfaces. French chalk or talcum powder rubbed over an oily surface removes residue oil and scum. NEVER use a solvent such as white spirit to clean hands; use vegetable oil or a professional-printmaking hand cleaner. Before printing use a barrier cream. When using or mixing any chemical, ALWAYS wear protective clothing, rubber gloves, and goggles or glasses.

Keep tools sharp, as these are less likely to slip and cause cuts than blunt tools or tools on the turn.

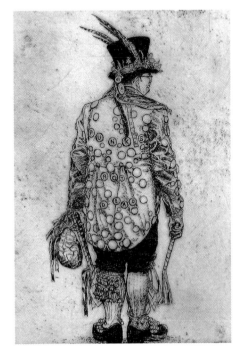

John Hewitt, *Punk's Not Dead*, etching, 23 × 23.5 cm (9 × 9¼ in.)

1 MONOPRINT AND RELIEF

Original and innovative prints can be easily and inexpensively produced using both of these techniques, which are based on the use of a surface roll of inks.

Monoprint

With this method a unique print is produced from a surface. Monoprint is different to the other printmaking processes in that to prepare the print all that is needed is simply to roll a firm, flat surface such as glass, stone or metal with a thin layer of printing ink. Then apply a little pressure and a print is produced.

Monoprints give interesting, experimental and unusual results, and need only basic tools and equipment to produce.

The following materials are all used with this technique: water-based and oil-based ink, pencils, paintbrushes, masking tape, lots of different paper and card, rags, a roller, string, hand burnishers, and a smooth flat surface for printing such as glass, stone or metal. Use vegetable oil to clean oil-based ink.

Workbench

Janie George, *Lotus*, monoprint, petals from one cut out inked with oil based blend and pressed onto old zinc litho plate repeatedley and run through an off set litho press. The black and white cut outs printed on a direct litho press.

Roll a thin layer of ink over the printing surface, then cover with paper and draw. When the paper is peeled away, an impression in reverse of the drawn image is transferred from the inked surface to the paper. This can be repeated and redrawn in several colours, either at random, or in lines drawn through paper, or on paper laid on the inked surface and burnished. Whenever the paper is peeled back a different image will have been transferred from the inked surface to the paper. Any drawing utensil will produce a print: a pencil or a piece of stick, the blunt side of a knife, the tip of a spoon or the top of a paintbrush. The more heavily the drawn line is pressed, the more textured it will be. Moreover, different papers have different effects; for example, thin paper is less textured. Although a one-off print, several variations can be produced. The first print is a positive, but if printed again it becomes a negative.

Textured paper, small pieces of fabric, as well as string or sandpaper laid on the inked surface will print on the paper as well as the inked surface. Reprint, add and take away marks with a cloth, and print again. Areas can also be masked with paper pieces. Water-based or oil-based ink can be painted directly onto the surface and burnished. Finally, the prints can be used as part of a collage, cut up and put back together.

Monoprint is an experimental process where lots of ideas can be carried across into other printing methods.

Relief

The area that is cut is depressed into a surface and does not print. Ink is rolled onto the flat uncut surface. This surface forms the print.

Woodcut

This is cut from a plank with a natural grain. The wood grain can be utilised within the image. Plank woods are a medium-to-hard surface to cut. Plywood such as birch ply gives a good grain with an easy cut.

Woodcutting tools are available in both specialist printmaking and general art shops. However, images can be cut exclusively using a heavy sharp blade knife. A pocket knife is useful, as are general chisels from hardware shops. A nail repeatedly hammered across and directly into a wood surface produces interesting marks, as do rasps, files and coarse sandpapers.

The following tools all cut both wood and lino:

- Medical scalpel (for scoring sharp, clean, delicate lines, as well as for dots and scraping)
- Stanley knife (a heavy, sharp blade knife)
- U-shaped gouge (a sharp hollow u-shaped steel tool that cuts both shallow and deep areas, excellent for cutting wood and available in various widths from 3 mm to 19 mm)
- V-shaped gouge (as above, cuts lines well, especially soft wood and linocuts)
- Chisel (clears large areas)
- Sharpening stone (to keep the tools as sharp as possible, as a sharp tool is less likely to slip. An Arkansas or other sharpening stone smeared with machine oil will sharpen tools well. Sharpen flat tools in flat circular rotation, rub V-shaped tools flatly up and down against the cut, and manoeuvre a U-shaped gouge from side to side.)

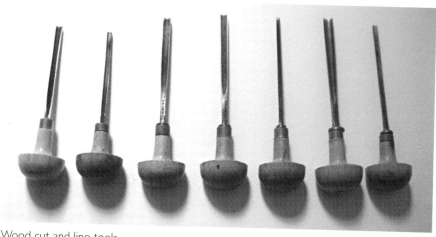

Wood cut and lino tools

Cristene Hoei, *Awakening*, relief print, twine, string and rope on hardboard, 50 × 70cm (19¾ × 27½ in.), monoprint.

Peter Dover, *Coastline 111*, Brittany, France, relief print/monoprint from found recycled wood, colour reduction burgandy and black, 76 × 92cm (30 × 36¼ in.). Hand printed edition 5, 1998 – present. The prints are continously worked and reworked within an ongoing series.

MONOPRINT AND RELIEF

Sandy Sykes, *Samaritan*, lino-cut, nail varnish and feather, 8 × 8cm (3 × 3 in.)

To cut the wood, sit it on a piece of cloth; this helps to stop slippage while also allowing freedom of movement. Then lightly sand the wood with sandpaper and paint it with Indian ink or poster paint. Draw the image onto the block with a white or light-coloured pencil. Go over this with a sharp knife; follow the grain, as this gives a clean edge to the cut. If there is a mistake or a chisel slip, a repair can be made by carefully gluing back the small piece removed in error.

Ian Rawlinson, *Guarding My Essence*, acrylic, wood cut relief, gold leaf and hazel, 122 × 92 cm (48 × 36¼ in.), 2004. Editioned

Michael Carlo, *Weather 3*. Colour reduction woodcut on MDF. 50 × 34 cm (19¾ × 13½ in.)

Alternatives to timber include MDF, a soft composite wood that cuts easily in any direction; and hardboard, which if lightly sanded to remove the shine cuts well, and can also be peeled to give an interesting texture.

A single piece of wood can be cut into shapes with a jigsaw. Curved, simple shapes can be cut and inked and reassembled. A white line appears between the shapes. Shapes and forms can also be pieced together using other surfaces such as plastic, aluminium, tin and cardboard. These should be glued to a board of equal height. If using cardboard, paint the board with emulsion or varnish to stop the ink from sinking into the board. This technique enables several colours and textures to be printed together.

Rubber erasers or small pieces of wood, card or metal can also be stamped onto paper or a printed image to add extra colour and shape.

Nana Shiomi, nine works from *One Hundred Views of Mitate*. Woodcut print, both relief and intaglio with water based inks and hand printed Japanese *baren*. Each image 34 × 34 cm (13½ × 13½ in.), edition 1998–2007. Mitate has been a fundamental concept in all Japanese art from the earliest time, Mitate involves a substitution of the intended subject by something simpler and vaguer. For example, the austere stones and raked sand of the Japanese garden are specifically designed to suggest a range of meaning, from islands in a sea, to tigers crossing a stream, to the solitude of human lives in the infinite. The breadth of possible meanings and the scope for free association permitted to the viewer are the benefits of Mitate. Nana Shiomi began *One Hundred Views of Mitate* in 1998 and the series will reach its full complement of 100 prints in 2007. She has chosen elements which she looks upon as universal, which refer to the iconography of traditional Japanese wood block.

Japanese *baren* for hand burnishing

Jacob Wachira, *Untitled*, colour reduction wood cut on MDF, 25 × 25cm (10 × 10 in.)

Kimani John Mbugua, *Untitled*, 25 × 25cm (10 × 10 in.) colour reduction, wood MDF

Wood engraving

A wood engraving is cut across the grain, so the blocks are a lot smaller than the planks used for woodcuts. A hardwood such as lemon, lime, pear or boxwood is needed for wood engraving. The tools are also different – very small chisels no larger than two millimetres in diameter and cut from reinforced steel.

The technique allows for the image to be cut in any direction in great detail. Wood is normally used, but the same technique can be applied to metal or Perspex.

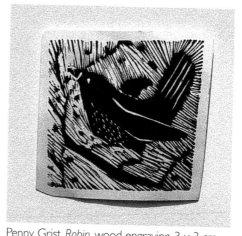

Penny Grist, *Robin*, wood engraving, 3 × 3 cm (1⅛ × 1⅛ in.)

Before cutting the woodblock, plane and polish the surface until very smooth. This stops the knife from slipping. Paint the wood surface in black Indian ink or gouache, and draw the image onto the block with a light-coloured or white pencil before cutting. This aids visibility, as the cut lines against the natural colour of the wood are difficult to see.

The blocks are usually small, depending on the diameter of the tree and the pieces produced from it. Have a small practice block to hand to try out different ways of producing a variety of lines and marks. Burnishing and filling, as in woodcutting, can rectify any mistakes. The blocks can then be successfully printed by hand.

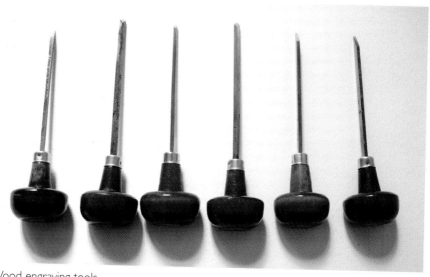

Wood engraving tools

Hernán Alvardo, wood engraving, untitled, 11.3 × 18 cm (4½ × 7 in.)

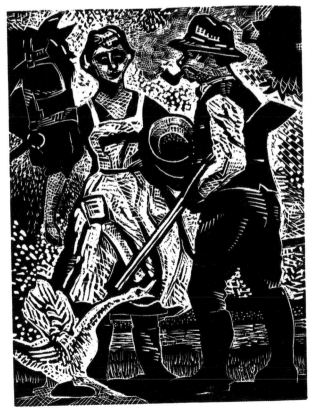

Kate Dicker, *The farmer and his wife*, engraving on Resingrave, a material developed by Richard J Woodman as a low cost alternative to Boxwood. It is a softer material than hardwoods cut across the grain and is capable of fine detail. 10 × 7.5cm (4 × 3 in.), edition 75.

Linocuts

Linoleum is a manufactured cork, or a composite of cork powder and rosin, with a canvas backing. It can be cut in any direction, though there is also an invisible, fine, greasy surface coating that needs to be removed before cutting and printing.

The surface can be degreased with either household cleaner or lemon juice combined with either charcoal or chalk, or the surface can be given a light scrubbing with very fine sandpaper to remove the invisible greasy film. Domestic lino or rubber flooring offcuts are relatively inexpensive and are worth trying.

If lino is slightly warmed it becomes malleable and has a tendency to curl and warp. Therefore, mount the lino surface onto a piece of wood or plywood, and rub with sandpaper before cutting. Paint the surface with black Indian ink and draw onto the block. Lino works well in colour reduction and multi-block printing. There is no grain, and the surface is smooth and can be cut in any direction. Textures can be worked into the surface with a knife or any other relief-printing tool. When cutting and clearing an area intended not to print, cut shallow, as the ridged marks left in the cut produce great effects, but can be removed later if not required. Coarse sandpaper scratched fiercely over areas of the block gives a good texture and tone when printed.

Caustic soda

A solution of caustic soda (sodium hydroxide) diluted in water and painted directly onto the lino will give a completely different effect. The corrosive solution eats into the granular surface of the linoleum by etching into it, leaving a distinctive, rough, grainy surface that prints as a tone and texture. A weak solution – one-part caustic soda to ten parts water – gives a slow and careful etch. However, caustic soda can burn, so care needs to be taken. Make sure to use rubber gloves and wear a mask.

To mix the solution pour eight parts water into a plastic or glass jar; then add one part caustic soda, followed by the two remaining parts of water. Stir the mixture to prevent crystals from forming. The mixture will heat up when freshly mixed, so it needs to be placed either in a well-ventilated room or outside, and allowed to cool. To thicken, add a generous teaspoon of powdered wallpaper paste to half a jam jar of solution. When painted onto the surface of the lino the mixture will then stay where it is needed to etch, and not run.

Etching lino can take anything from 20 minutes to several hours, depending of the strength of bite required. Protection of the areas that are not to be etched can be used to great effect. There are several products, resistant to caustic soda, which can be applied to the block before the caustic soda and water mixture is painted on. Draw the image onto the lino using a light coloured pencil, then paint the areas to be etched; or else draw or paint the image onto the lino using a wax-coloured crayon, melted candle wax, wax resist, soft shoe polish or varnish. Paint the caustic soda solution over the

Mandy Bonnell, End paper, *Second Life of Shells*, lino cut, 32 × 23cm (12½ × 9 in.)

whole lino block, and the waxed drawn image will resist the soda solution, leaving a textured background. Alternatively, the whole surface can be coated with wax, and when this is dry the areas to be etched can be scraped and scratched away with a sharp knife blade.

Whichever method is used, the wax needs to be thinly applied. Place in a well-ventilated area or outside, paint the caustic-soda solution onto the areas of lino to be etched, and leave for approximately one hour. If a deeper etch is required leave for up to six hours, checking the block regularly.

Placing the linoleum block between sheets of newspaper and running a hot iron over the whole thing can remove the candle wax. The newspaper will absorb the melted wax. If a varnish has been used, check which base it contains – paraffin, white spirit or ethylated spirits – and use the same substance to

clean and remove the varnish. The linoleum block can be printed as a surface roll, or as an intaglio print, where the etched line holds the ink.

Embossing

Embossing is a technique whereby a block – whether wood, lino, plastic, cardboard or metal plate – is printed without inking, and the print impression on the paper is produced by pressure. A printing-press pressure is usually required, though good results can also be achieved printing by hand, with a lot of pressure, using damp paper.

Metal relief assemblage

Thin aluminium, tin, zinc or copper are all soft metals. A variety of cuts, dots and linear detail can be used to great effect on these surfaces. A tin-can lid is ideal – as are discarded CDs – to cut into, stamp and reassemble. Lots of things can be used to make the printed image. Aluminium is a good base surface. It is light and cheap, as is wire mesh. However, beware of sharp edges, which can be dipped in melted candle wax to protect the hands.

The assemblages can be printed as a surface roll or intaglio – where an engraved line is inked and printed while the surface of the block is wiped clean. Whatever you do, make sure the surface is an even height or at the very least you won't get a good print.

Plaster relief

For this technique you will need plaster of Paris, builders' plaster or dental plaster, water, plastic mesh or hessian, a wood frame one inch deep, a glass or aluminium base, and oil or petroleum jelly.

Place the wood frame on the greased base surface, pour the wet plaster into the frame until halfway up the sides, lay the plastic mesh and continue pouring until full; this will strengthen the plaster block. Smooth the top with a ruler or a strip of wood, then leave to dry. When dry and set, separate and remove. Seal the surface with shellac, or acrylic medium. All sorts of cutting tools and textures can be applied across the surface.

When printing, use oil-based ink and print by hand, without excess pressure.

Cardboard

Cardboard or cardboard box is versatile and does not have to be particularly thick.

Two pieces of card will do, glued carefully together with wood glue to a baseboard of MDF or hardboard. A thin, even coating of varnish or household paint can then be applied to the surface. This will stop the ink from sinking through the cardboard. The surface can be collaged with flat found papers, or cut into with a knife or blade. A single fine line can be used freely and will give a fine line print. For thicker lines, two fine lines can be peeled away to form one thick line. If large areas need to be removed these can be peeled completely

with a knife or blade. Masking tape, sellotape, crinkled paper; sandpaper or any cut paper shapes can be glued to form a collage, as can fabric and string. The finished surface will need sealing with lacquer, hairspray or shellac varnish. Print using oil-based ink.

If large flat areas of colour are needed, glue an extra card layer to the existing surface.

Hand-printing

Once the printed surface block is ready for printing, oil- or water-based printing ink should be thinly and evenly rolled onto a smooth surface such as glass or aluminium using a roller. Anything that has been cut away will not print, as defines a relief print. The inked surface needs to resemble a dense even layer of ink; if too much ink is rolled onto the block the ink can fill into the cut areas. For hand-printing, a backing sheet of paper is required, such as newsprint, cut to the same size as the printing paper. The printing paper needs to be smooth and not heavyweight. This can then be very firmly and evenly rubbed using hand-burnishers, such as a wooden spoon or a Japanese baren, which gives smooth, even pressure. Keeping one hand firmly on the surface, lift an edge to see how the print is progressing.

For multiple block and colour-reduction prints, the backing sheet becomes the registration: mark which is the top of the paper and also pencil-mark where the print block sits within it.

Printing with a press

Albion presses produced in the 19th century can be expensive and difficult to find. However, it is possible to purchase them second-hand through printmaking advert sites and printing engineers. For artists who are just beginning and who wish to work in more than one printing area, an etching press will work extremely well, the pressure being only half that experienced when producing an etching. Bookbinding presses or nipping presses also work well.

The drawing of a press designed by printmaker Michael Carlo (p.26) is based on a nipping press with base and top layers made from chipboard. It holds from the centre a large central screw with a nut at the top. The sides and top are steel. It can be screwed

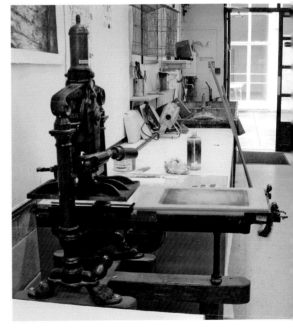

Small Albion press

MONOPRINT AND RELIEF

onto a firm wooden table and could be produced or put together as an affordable working press.

To print from a press, ink the image on the block as for hand-printing, and place on the bed of the press – if using a nipping press, place onto a piece of wood and slide into position. Cover with soft packing; have to hand thin packing, medium packing, or a thick layer such as newsprint or felt.

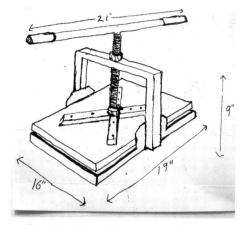

Drawing of a relief press to make.
Courtesy of Michael Carlo

TIP

Always place hard stuff on the bottom and soft stuff on top; the pressure is released from a central source, and the soft packing allows an even spread. The pressure is correct when there is resistance but not so much as to be painful.

Multiple block printing

Blocks can be made of the same material or a mixture of wood, linoleum or card. Keep them the same size if hand-printing.

Put together a key drawing. Use the colours of the print and draw the image the same size as the blocks. Draw onto the blocks, separating the colours to be used. If three blocks will be used for the finished print, mark each print with the colour to be used.

Colour reduction

One block is required for this method, which is a means of producing an image of several colours by process of elimination. The colours to be printed can move from light to dark or from dark to light. If printing from light to dark, the white areas need to be cut away first and the lightest colour printed. Next, cut away the colour that has been printed and overprint the next lightest colour. This is then repeated until the darkest colour is reached.

For embossed prints, a definite image is produced without ink. For deep embossing a press is needed, but good results can be achieved by printing by hand, with a lot of pressure, using damp paper.

2 INTAGLIO, DRYPOINT AND ETCHING

 Intaglio

The word 'intaglio' derives from the Italian word meaning 'to carve or engrave'. This technique covers etching, drypont and aquatint processes and incorporates many creative and affordable methods. An intaglio print is the opposite of a relief print.

The scored, cut, drawn or etched image is the area that will print. The ink is worked into the indented areas while the surface is wiped clean with muslin. An etching press is needed to produce the print, as heavy rolling pressure forces the paper into the inked marks of the plate. The metal used for any of the intaglio techniques need not be more than 18 gauges, which is less than a millimetre.

Drypoint

This is a direct intaglio process, as the printed image is produced by scoring drawn marks into a metal plate with the fine point of a steel tool. The scoring must be deep enough to remove a thin line of metal, leaving a burred rough edge. Many different marks can be produced using a line in different and inventive ways. Power tools, if available, can also be used to create depressed and unusual marks. Cross-hatching lines at different widths and depths can achieve tonal gradations, or sandpaper roughly scratched across the plate works very well. A surface tone can be achieved by painting a thin layer of household emulsion directly onto a metal plate. When it is dry and printed it will give a soft watercolour quality.

Carborundum grit is a powdered abrasive, traditionally used to sharpen woodcut tools and for graining lithography stones. It is purchased cheaply through printmaking suppliers. Carborundum can be used to great effect within drypoint and other intaglio techniques, to give marks that range from subtle brushwork to dense velvet textured tones.

In a container, mix together a small amount of water with acrylic paint and stir well. Add carborundum powder so that the mixture is the consistency of thick cream. Paint this mixture onto the metal plate and leave to dry. When dry, the plate can be printed.

A soft metal such as aluminium works particularly well for all drypoint techniques and commercial printers often sell used plates very cheaply. Heavy-weight mounting card can be successfully cut into with a sharp scalpel knife and areas can be peeled away. The card prints well, but be aware it can break down after just three or four prints have been taken.

Tools

Intaglio tools can be used for both drypoint and etching.

Traditional drypoint tools are made from steel and have a sharp tip. They are available in two weights, heavy and light. These tools can also be used to gently draw an image through an acid resist ground in etching. Affordable alternatives include a compass point or a long sharp steel nail. Sharp dentists' tools also work well.

Roulette wheels are small steel-toothed rotating drums attached to a handle. They resemble pastry cutters and when firmly rolled across a plate the marks left on the plate give good tone. They can also be used through a hard wax ground in etching.

Burnisher scrapers are an essential tool in both drypoint and etching as they can erase unwanted marks, by scraping and burnishing away-unwanted areas.

Traditional tools are available in all printmaking suppliers. However good hardware shops should not be overlooked as alternative suppliers.

Etching

This process involves using a metal plate where the drawn image is etched by a corrosive to obtain the incised marks.

A non-acidic substance, such as wax, is melted onto the metal plate and when cool and firm the wax ground is drawn into leaving areas of metal exposed. The exposed drawing is placed in a shallow bath containing the corrosive and the image is literally eaten into the plate.

Metal

Zinc is a soft metal very suited to etching and drypoint work. It is relatively cheap, though it is still advisable to shop around metal supply merchants, as the price varies. Zinc is excellent for printing in black and earth colours. As zinc is soft, the natural impurities within it are revealed when printing white and light-coloured inks, lending them a muddy hue.

Copper is soft, with few impurities, and thus well suited to all etching and drypoint techniques. It etches cleanly and prints all colours well.

Steel is a hard metal with a natural plate tone. It lends itself well to colour printing. As it does not discolour, the natural tone is reinforced when large open areas are etched. This yields a rich dark tone that can then be burnished to produce an image ranging from dark to light. However, steel will rust and needs to be protected with oil and kept in a dry area.

Overall any metal used needs to be prepared through degreasing and polishing. Metal polish should be used to bring the metal to a fine shine. For degreasing, use a weak solution of household ammonia (do not use any other kind) mixed to a paste with ground white chalk, or whiting. Add ammonia to water, NOT water to ammonia, in the ratio of approximately eight parts water to one part household ammonia. Alternatively, a piece of wet charcoal rubbed

Pierre Julien, *The Mind Garden*, etching, 50 × 50 cm (19¾ × 19¾ in.)

James Beale, *Harctsour*, 18 × 8cm, etching and aquatint. Edition

INTAGLIO, DRYPOINT AND ETCHING

David Harding, *Bird*, etching, 41 × 53 cm (16 × 21 in.)

with vigour across the plate will perform the same function, while other degreasing options are household cream cleanser or washing powder. These should be applied with a soft cloth and rinsed off with water.

Filing

The plate may have very rough edges, which will need to be filed using a metal file. File at a 45° angle, working along the edges of the plate. Lightly sand and burnish until smooth.

Resist grounds

A ground acts as a protective coating to the metal. It is also a surface from which to draw the image onto the plate. It shields the unexposed metal while the acid is etching the exposed metal marks.

There are two sorts of wax-based grounds, hard and soft, which are readily available from printmaking suppliers in solid and liquid forms. Liquid grounds can be tricky to use, but the solid grounds melted onto the metal plate with a roller or dabber work well. With care, both hard and soft grounds can also be made by hand, the raw ingredients being widely available.

Hard ground

Heat an electric hotplate or an electric ring. This should sit under a metal frame with legs, with a metal sheet over the top for good heat conduction. The

Roller and dabber

hotplate need only be hot enough to melt the hard wax ground. Place the prepared metal plate onto the hotplate and melt the wax in a strip across the centre of the plate. Using a roller or a leather dabber, evenly spread the melted wax ground. When there is an even coating, remove and cool.

To draw into the hard wax, use either a sharp hard pencil, a blunt needle set into a wooden handle, a compass point, a cotton-wool bud dipped in white spirit, or sandpaper. Each will have its own quality of mark and line.

The depth, thickness and strength of line can be controlled by the length of time that the plate is etched in the etch solution. The drawn image will print in reverse. A hard-ground etch is crisp-edged and clean.

Soft ground
Turn off the hotplate once it is hot, as the ground needs warmth, not heat, to melt; if too hot, the ground will not stick to the plate surface. On the warm surface, place the prepared plate and lay the ground as before. Even when cooled the ground will remain tacky.

Draw onto the plate with a pencil through a sheet of paper. Take care that the texture of the paper does not transfer onto the plate, as any incidental marks will etch. These marks are called 'foul biting'. Varnishing the plate surface prior to etching can help prevent them, though sometimes they can also lend very interesting tones and textures to the finished print.

As the ground remains soft, found objects and material textures can be pressed into the wax prior to etching.

Liquid grounds
The same process applies to both hard and soft grounds when in liquid form. Stand the prepared plate in a shallow tray. Carefully pour an even layer of ground across the very top of the plate. The tray can catch the drips. Very

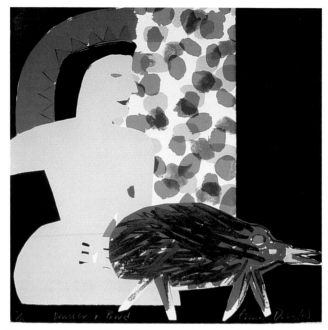

Emma Douglas, *Bather and Dog*, silkscreen and etching, 57 × 38cm (22¾ × 15 in.)

carefully remove to dry, a process that can take up to 12 hours, and pour the excess ground back into the bottle.

Health and safety precaution

When working with grounds, it is important to wear rubber gloves, a dust mask and sensible clothing. Work only in a well-ventilated area. The recipes are not suitable for producing in a domestic kitchen. Remember to use an electric ring for heating; do not use flame-fuelled heat.

The following recipes have been tried and tested since the time of Rembrandt and are taken from *Etching, Engraving and Intaglio Printing* by Anthony Gross.

Recipes

The ingredients are measured by weight not volume. You'll need the following equipment: an electric ring, measuring scales, a large saucepan and a wooden spoon, plus baking parchment, ice-cube trays and waxed paper cups

Hard ground

- Beeswax 2 equal measures
- Asphaltum 2 equal measures
- Colophony resin* (fine-powdered) 1 measure

*Colophony resin is sold as aquatint resin. If in a lump, it can be ground using an electric blender or a pestle and mortar.

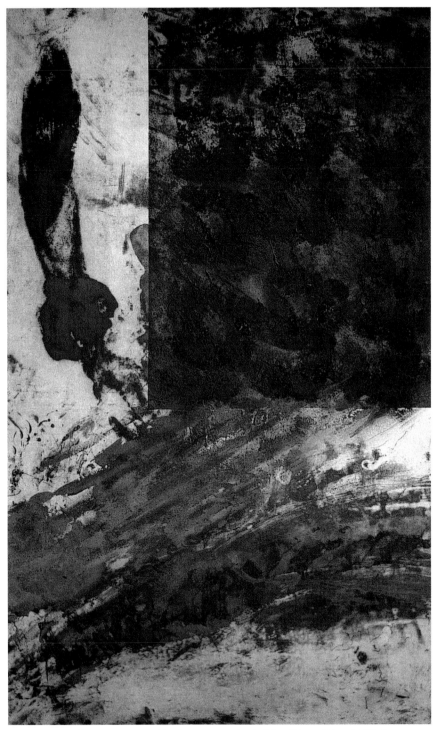

Ian Rawlinson, *Reach*, etching with silkscreen and grit, 79 × 54cm (31 × 21¼ in.)

Melt the beeswax in the saucepan over a moderate heat. Carefully stir in the asphaltum, followed by the colophony resin. Turn down the heat to a very gentle bubble, stirring continuously until everything has dissolved. Keep the pan on this low heat and simmer slowly for approximately three hours, stirring every 15 minutes.

Remove the pan from the heat and allow the mixture to cool and thicken. Line individual baking moulds with baking parchment and drop in spoonfuls of the thick mixture, or pour into small waxed paper cups or greased ice-cube trays.

Soft ground

Make the hard ground as above. Before it cools and thickens pour half the hard ground into a clean saucepan. Add half of this weight in tallow or lard and stir into the mixture. Stir continuously as before for 15 minutes. Add 10% of Vaseline or petroleum jelly and continue to stir over a gentle heat for a further 10 minutes. When cool, pour into moulds as above.

Etching

Preparing to etch

The back and edges of the plate will need protection from the etch solution. Paint the back of the plate with a turpentine-, paraffin- or spirit-based varnish. Alternatively, cover completely with parcel tape.

Etching techniques

Ferric chloride etches zinc, copper and steel. Do not etch plates of different metals in the same solution.

As an etching agent, ferric chloride is safe to use in a ventilated area and does not require specialist fume cabinets. Available in liquid and crystal form, in its neat state it is 45-degree Baumé, known as strong. If possible, purchase liquid ferric chloride.

Dilute ferric chloride with water by 50%, ALWAYS mixing ferric chloride to water, and not the other way around. Wear protective clothing and rubber gloves at all times, and keep the solution safe in plastic bottles. When etching a plate use a plastic photographic tray, pouring into this enough ferric mixture to cover the plate.

Pour enough ferric chloride into the plastic tray to fully cover the plate when immersed in the solution; this should be no more than half a centimetre or so. The plate will begin to etch as soon as it is placed in the acid tray. A short etch gives a light mark. A light to medium etch will occur in 15–20 minutes. The plate can be removed, areas can then be stopped out with varnish or liquid ground, and the remaining parts re-etched.

Etch the plate for no longer than 40 minutes at a time, as salt deposits will settle from the ferric chloride onto the etching plate and stop the plate from etching further. Remove the plate from the ferric chloride, rinse with water

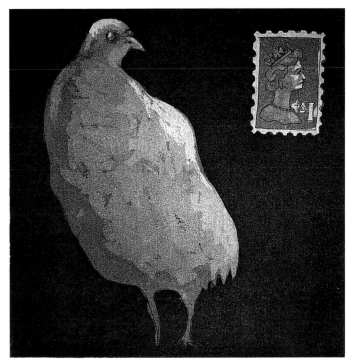

Peterson Kamwathi, *Pidgeon*, etching aquatint, 16 x 15cm (6⅓ x 6 in.)

and place in another tray containing a mixture of acetic acid and water. Dilute neat acetic acid in the ratio of ten parts water to one part acetic acid, ALWAYS mixing acid to water, and not the other way around. Leave for 20 minutes. This will clean the salt deposits collected from the ferric chloride. The plate can then be returned to the ferric chloride for further, deeper etching. Alternatively, a strong vinegar bath will work just as well, and is safer to work with than acetic acid.

Ferric chloride has a limited lifespan. When it turns a mud green it needs to be thrown away; thankfully it is safe to pour down an outside drain.

Other etching techniques
Open bite
For an open bite is where selected areas of the plate are left 'open' with no resistant coating. When etched, the area will print in a light tone with a very fine line edge.

Sugar lift
Sugar lift is a solution saturated with sugar – meaning that you keep adding sugar until no more will dissolve. The image is painted onto the plate as a positive.

To make the sugar-lift solution, you'll need a screw-cap jar, water, granulated or caster sugar, black gouache and washing-up liquid. Granulated sugar gives a grainy texture when it sticks to the plate, while caster sugar gives a smooth lift.

Quarter-fill the jar with water, add sugar and shake. As the sugar dissolves, add more until the mixture becomes saturated. Then add a good squeeze of black gouache and a few droplets of washing-up liquid. Mix and leave overnight. Degrease the etching plate and paint the solution onto the plate. When dry it will retain a slightly sticky feel when touched.

Roll a soft ground over the entire surface of the plate, and when this is cool place in a tray of warm water. The sugar solution will lift from the plate.

The sugar lift can etch as an open bite or if a tone is required it can be painted onto a resin aquatint, and rolled as if it were a soft ground.

Aquatint

Aquatint gives a non-linear tone or tint and is produced by covering the plate with fine dots that are resistant to the etch. Powdered colophony resin is the traditional method. A short etch gives a light tone, and several tones can be achieved on one plate.

Health and safety precaution

The traditional way to apply a resin aquatint is using an aquatint box. Without professional air-extraction, which is very expensive to install, this is a hazardous enterprise. With practice, hand-shaken resin in small quantities, using a dust mask and rubber gloves in a well-ventilated room, will give good results. Place the powdered resin in a jar, cover with two layers of scrim and fix with a rubber band. Shake an even layer onto a degreased plate. Melt gently on a hotplate and cool. Paint varnish or liquid hard ground onto the plate to cover the areas not to be etched. Using a test plate as a guide, etch for the required time.

It is important, before working on the prepared plate, to make a test plate. When using ferric chloride, for example, there are only approximately 12–15 minutes in which to achieve a rich solid dark tone, so it is vital to know how the metal you are planning to use will behave in the etching solution. To test, etch a piece of the same metal for 15 seconds, remove and cover one strip with parcel tape. Repeat for 1 minute, cover the next strip, then every three minutes, covering a further strip each time, until after 15 minutes the whole plate is etched. When the plate is then printed, a clear range of tones will appear from which you will be able to determine the ideal etching times for different areas of your prepared plate.

Resin is spirit-based, and is removed from the plate with methylated spirits.

The following aquatint resists are less fragile and can be etched for longer periods.

Salt aquatint

Place a hard ground onto a prepared plate, remove the plate from the hotplate and, while it still holds heat, sprinkle salt evenly over the surface. When cool, place the plate in a tray of warm water, allowing the salt to lift away. For an alternative effect use a soft ground. Stop out the areas that are not to be etched.

Hugh Sanders, Untitled etching edition 5, used aluminium litho plate etched randomly in caustic soda with car sprays, and wax crayons as resist. The metal plates were then assembled with a pot riveter and selected areas pierced, scored and folded. The plates are blind embossed on an etching press using a sponge blanket on a heavy-weight mould-made paper, which prior to printing had been stained with vegetable dyes and diluted stop-out varnish. the resulting image was then cut out and polished using graphite and metal polish. Small sections of the original plates were attached to the print using glue or bolts. Selected areas were treated with iron powder. 76 × 100 cm (30 × 39½ in.).

Stipple

Dip a toothbrush into liquid hard ground or varnish. Next, take a palette knife and, holding the toothbrush 10–15 cm (4–6 in.) above the surface of a degreased metal plate, brush the toothbrush carefully across the blade of the knife, and the surface of the plate will be splattered with the ground or varnish.

Car spray paint

First, make sure you read the health and safety instructions on the spray can. Next, lay a prepared plate onto paper and start to spray the paint gently from 5 cm (2 in.) above the top plate edge to 5 cm (2 in.) below the bottom edge. Spray lightly from a height of 30–50 cm (12–20 in.).

Paper

Lay a sheet of heavy cartridge paper or fine-to-medium sandpaper over a prepared soft ground. Release the pressure from an etching press and take a print. Stop out the unwanted tonal areas.

Spit bite

This method gives a soft watercolour effect. Have ready two plastic or glass jars. Place a prepared resin aquatint plate in an empty plastic tray. Fill one jar with water and into the other decant a small amount of neat liquid ferric chloride. Paint the ferric chloride directly onto the plate. Add droplets of water to create a watercolour effect. This process will take 10 to 15 minutes. When finished, pour the jar of water completely over the plate to diffuse the ferric chloride, and rinse. Remove the resin aquatint with methylated spirits.

Preparing to print

Before applying ink to the plate, use a mixture of vegetable oil and a small amount of white spirit solvent to remove the acid resist ground that has been used to protect the plate during the etching process. A safe commercial oil-based solvent is Tonic FR, available from printmaking suppliers.

The etching press

Traditionally, it is not possible to print etched plates without the aid of an etching press. A new press can be very expensive depending on the size, but also versatile, as it can also deliver relief and lithography prints. It may also be possible to obtain a second-hand press.

An etching press is comprised of two polished steel rollers, which sit on top of each other. Between these lies a steel plate or bed. The roller thickness is dependent on the size of the press. A press bed to print paper 56 x 76 cm (22 x 30 in.) is approximately 2.5 cm (1 in.) thick.

The bed of the press sits on the bottom roller, while the top roller controls the pressure. The handle at the side controls the movement of the press. Large presses are geared, being very heavy to print; the very small presses are not.

Press manufacturers are available to talk to worldwide, as are printmaking groups, societies and specialist printmaking periodicals. Adverts for sale and purchase within these publications are also worth checking.

Small bench etching press, Hunter Penrose

Large geared etching press, Hunter Penrose

Blankets

You will need three press blankets to aid rolling pressure and an even print. These are specialist hand-woven felts available in printmaking supply shops. An alternative is to try bed blankets, or a thick piece of sponge. To fit the blankets to the press, release the pressure from the pressure points on top of the press and slide the blankets between the press bed and roller.

Pressure

Turn each point exactly the same distance as the other, and as tight as possible. Then release by one complete turn. Place un-inked, etched plate with dry paper on the press bed. Lower the blankets over the top and tighten the pressure. If the press is too tough to turn, release the pressure evenly, a little at a time. You will have found the correct pressure when the un-inked plate leaves an emboss of the image on the dry paper.

Paper

The process requires the paper to be moist and malleable, though not saturated with water. This will help in transferring ink from the plate to the paper. A plastic tray such as a photographic tray is ideal for this moistening-up process, as the paper can be immersed into it. Cartridge paper needs a 5-minute soak, while heavier-weight printmaking or watercolour paper needs to soak for 20 minutes. It is then dried off a little, sandwiched between sheets of blotting paper.

Alternatively, sponge the paper on one side generously with water or spray using a plant spray. With this approach, several sheets need to be placed on top of each other, completely wrapped within a plastic sheet and left overnight to settle and absorb water. Note, however, that if wet paper is left wrapped in plastic for several days, it will go mouldy.

Ink

There are good specialist water-based inks for etching. These are available from printmaking suppliers and are applied to the plate using the same procedure as with oil-based ink. There is also plenty of choice among oil-based inks, in different strengths – weak, medium or strong – as any oil-based printing ink can produce a good print. Tinned oil-based inks to choose from include those intended for etching, lithographic or relief printing.

Ink for printing is also straightforward to make yourself from ground pigment and copperplate oil, i.e. linseed oil that has been double-boiled. The ink needs to be stiff, not greasy. It is not possible to give exact quantities of oil to pigment, as pigments vary in texture and density. However, the most common mistakes when making ink are too much oil and too little mulling.

Making ink

To make your own ink you will need a heavyweight glass or marble muller; a slab or flat surface for grinding glass, stone or metal; two palette knives and a dust mask. For the ink itself, you will need both medium and thin copperplate oil, pure pigment, and some small pieces of plastic.

Place the pigment right in the middle of a clean, smooth surface. Form a small hollow in the centre of the pigment and pour a very small amount of the medium oil. Mix with the palette knife to form a stiff paste. Move the paste aside, taking a small amount back to the centre of the slab, and begin to work it with the muller backwards and forwards across the slab until it is smooth and shiny. Scrape up and move to the other side. Repeat the process until all the inky paste has been worked over. There should be no trace of grit at all left in the ink, which should be a thoroughly smooth and gleaming mass. If it is still too stiff add a very small amount of thin copperplate oil.

The secret to good ink is the ratio of oil to pigment. Oily ink is very hard to remove from the plate – it leaves a smear and does not hold in the etched marks.

When you are happy with the ink's consistency, scrape it onto small pieces of plastic and wrap tightly.

Inking the plate

For this you will need ink, tissue paper, heavy mounting board pieces, French chalk or talcum powder, and scrim/tarlatan or cheesecloth.

Make sure the surface of the plate is clean. Rinse the scrim in water to remove the starch. Then place the ink onto a flat surface and, using a piece of

Janet Wilson, *Osymandias*, carborundum print, 106 × 106cm (41¾ × 41¾ in.)

the card, work the ink carefully across the plate. A second card run over the surface will remove any excess ink.

The scrim needs to become a firm smooth pad. Firmly sweep the pad with twisting movements across the plate, making sure it is removing ink from the plate surface. Do not scrub, as the ink needs to remain in the etched areas.

Next, take a piece of tissue paper just in the palm of the hand and, using gentle pressure and circular movements, evenly work it across the plate. This should be sufficient to print a first proof of the plate. If the plate requires further cleaning, a very small amount of French chalk/talcum powder, smoothly rubbed into the palm of the hand and dusted off, can be swept across it.

Always clean the edges of the plate with a rag.

Printing

Cut a backing sheet of newsprint the same size as the printing paper and place it on the bed of the press. Centre the inked plate by eye and place it on top, then lay the damp printing paper corner to corner onto the backing sheet. Think of the

whole assembly as a sandwich, with the inked plate as the filling. Gently bring the blankets from the press over the top of the 'sandwich' and turn the press wheel. The heavy rolling pressure of the press forces the inked plate into the damp paper.

Printing without a press
Plaster
Ink the metal plate as described above. Have ready a wooden frame or shallow box lined with plastic sheeting greased with Vaseline or petroleum jelly. Mix enough plaster so that when the process is finished, the depth of plaster inside the frame or box will be at least one inch. Pour in half the plaster, lay down a piece of scrim or fine plastic/wire mesh, and continue to pour the plaster until the frame is almost full. When the plaster has almost set, lay the inked plate face down into it. When it has set but is not yet completely dry, remove the plate from the plaster. The inked image will be set perfectly into it.

Multiple-plate printing
A combination of more than one plate for one finished image is actually straightforward to print. However, the printing paper and backing paper need to be as large as possible. Also, keep the plates the same size. Ink and prepare them for printing.

Print one of the plates. Once the plate is through the roller, stop and lift the paper over the top roller, leaving one edge of the paper trapped under the roller. Mark two edges with a pencil, take two thin strips of metal or wood approximately 10 cm (4 in.) in length and lay them at right angles against the metal plate. Hold firmly, and carefully lift the plate off the press. Place the second plate into the press, making sure that it won't print upside down. Gently lay the printing paper back over the second plate and continue printing.

Collage
Also known as chine collé, this technique involves paper pieces being collaged into the print. Any weight of paper can be used, as can fabric. A dry watercolour, a drawing, a photocopy, newspaper or simply coloured tissue can be incorporated into the print as an integral part of the image. Plan before printing where the collage is going to be placed.

Ink the print, prepare the printing paper and place the plate on the bed of the press.

Have ready a water-based glue such as a Pritt® Glue Stick. Carefully, spread a thin layer of glue across the back of the collage. Place the collaged piece face down on the inked plate with the glue facing upwards. Lay the printing paper over the whole assembly and print.

Hand-colouring
With this technique small areas are hand-painted with coloured printing inks onto the inked plate prior to printing. Use only a thin layer of ink

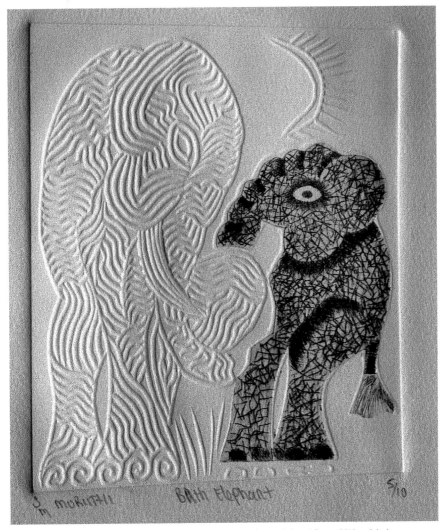

Simon Muriithi, *Bath Elephant*, drypoint and lino emboss, 16 × 15cm (6⅓ × 6 in.)

and blot twice with tissue paper. Too thick a layer of ink will cause a bleed when printing.

Counter-proofing

With this technique an image is transferred from one sheet of paper to another from the plate using tissue paper or newsprint. Ink the plate and place on the press for printing. Lay dry tissue paper on top, followed by a damp sheet of cartridge paper, then print. Remove the plate from the press and peel the tissue print from the cartridge paper. Place a piece of card larger than the paper to be printed onto the press. On this, place a fresh piece of dry printing paper. Lay the tissue paper ink-side down onto the dry paper, and print. The image will

transfer. This technique can be used in a number of ways. The tissue could be cut, reassembled and printed; or the tissue pieces can be laid onto another inked plate and printed.

Combination prints

Combinations of technique and process can be straightforward to achieve. The key to working in this way is to plan your work, and keep registration straightforward. You need to ensure that the separate metal plates, or the combination of print processes, print in the correct position on the paper each time.

When combining intaglio techniques, which print onto damp paper with a dry-paper printed process, print the dry paper part of the image first as this will make the alignment easier since paper stretches when wet. Also avoid detailed and close registration with combination processes as shrinkage can occur when the damp paper from the intaglio print dries.

Drying

To dry prints, lay blotting paper onto a flat surface. Place the damp print on this, and cover it with tissue paper and another sheet of blotting paper. Stack the prints, following the same procedure for each one, and place an extra sheet of blotting paper on the top of the stack of prints, followed by a board with a weight on top.

Prints can take from one to four weeks to dry, so make sure to change the blotting paper and tissue paper at least once to keep the prints flat. Alternatively, tape the print to a wooden board using paper gum strip.

3 LITHOGRAPHY

Lithography is a process that requires materials and equipment from specialist printmaking suppliers, but you can achieve very good results even with minimal materials and processes.

The term 'lithography' is taken from a Greek word meaning 'stone writing'. Within the contemporary print industry, the lithographic process is used photographically to print magazines and advertising. It is a process that has developed and survived commercially since it was invented more than two centuries ago.

Lithography is a planographic process, meaning that it prints from a surface plane. Lithographic prints are produced from a treated, degreased, smooth but porous flat surface, traditionally limestone. The process relies on the fact that oil and water do not mix. Commercially treated zinc and aluminium plate print well using lithography, as does a specially coated paper from print supply shops.

Traditionally, lithography is a painterly print process: subtle washes of watercolour can be painted directly onto the plate or stone with a greasy solution that dissolves in water. Greased crayons are used to give a pencil/coloured-crayon effect. It is usual to print on a specialist litho press, though an etching press is also fine.

For anyone new to the technique, there are workshops available offering access to lithography. Although a straightforward process, it does require specialist materials and workshop facilities. All the materials and chemicals for the process are available through printmaking suppliers.

This following section describes only plate lithography, as this process is easier to adapt to a smaller working environment. Stone litho is not the easiest process to set up, as equipment is not easy to find. For information on preparation, processing and printing on stone see *Stone Lithography* by Paul Croft (London: A&C Black, 2001).

Michael Carlo, *Earthwork 10*. Colour reduction lithograph. 20 × 18cm (8 × 7 in.)

Preparation

Litho plate can be obtained through specialist suppliers; zinc is recommended. It needs to have a fine, absorbent, even grain, which is produced using a graining machine. This grinds the plate using a combination of aluminium-oxide powder and water. The abrasive mixture agitates and lightly etches the plate surface, causing a chemical reaction.

The following materials will be needed for preparing a litho plate:
• Gum arabic
• Prepasol (a chemical acting as a degreasing agent)
• Rubber gloves
• Sponges
• Plastic measuring jug
• Bucket

Wear rubber gloves and protective clothing. Prepare a solution of Prepasol and water in a plastic jug in the ratio of ten parts water to one part Prepasol. Only mix Prepasol to water, NOT water to Prepasol. Lightly and evenly pour this solution over the plate, wash off with water, then dry. This process will ensure that the surface is completely non-greasy.

Next, using a sponge dipped into Gum arabic, spread a 5 cm (2 in.) margin down each side, and dry.

Drawing/painting

The following mediums are all effective for drawing or painting onto a litho plate:
• Litho Tusche (a liquid solution made from a mixture of wax, tallow, soap, shellac and soot. Although it is a greasy mixture it does dissolve in water.)
• Litho chalk, available in grades ranging from 1 (hard) to 7 (soft)
• China graph pencils (oil pastels can also be tried)
• Carbon paper gives a fine-drawn line.

Draw or paint the image onto the prepared surface, and treat as though it is a good-quality watercolour or drawing paper. Once the image is on the plate, it is ready for processing.

Processing

For this you will need French chalk and green etch – available from specialist suppliers, green etch is a gum arabic base solution combined with an etching agent.

Dust the image evenly with French chalk. Then, wearing rubber gloves, pour some green etch into the centre of the plate and thinly coat the entire plate with a sponge. If the green etch is applied too thickly, it will crack; a thin, very even coat, lightly buffed by hand, is what is required. Leave to dry.

Stephen Mumberson, lithograph, *Good Luck*, 27 × 35cm (10½ × 13¾ in.)

Printing

- Turpentine
- Bucket
- Water
- Two sponges
- Litho ink (available from printmaking and commercial print suppliers)
- Hair dryer
- Paper
- Large hard-rubber litho roller, diameter 10 cm (4 in.), length 30 cm (12 in.)

Offset litho press

Contemporary commercial printing presses stem from the original design of the offset litho press. It has a geared, moveable roller with a rubber blanket, which picks the ink from the plate surface and transfers it onto the paper. There are two steel beds, one to hold the paper and the other to hold the litho plate.

Offset litho presses can be found in the for sale/wanted section in printmaking periodicals, on printmaking advert websites, by word of mouth, and through printmaking groups and societies. However, an etching press can also be utilised to print a plate litho.

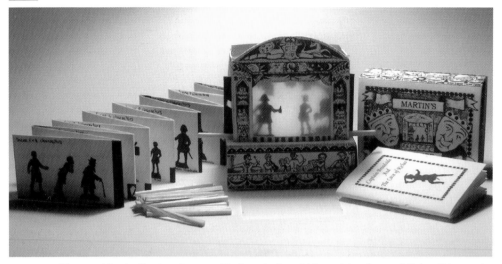

Thomas Martin, *Shadow theatre with Captain Broadside and the Curve of Riches*, lithograph editioned

Inking and printing

Before printing, have everything ready and to hand. Mix and roll out the oil-based litho ink onto a stone slab or heavy glass. Run a sponge over the printing bed of the litho press and clip the paper into position. Fill a bucket with warm water. Using a rag or sponge, sprinkle the surface of the litho plate with turpentine and gently rub out the image. Using another sponge, rinse off the green etch with water.

Keep the plate wet but not sodden, and roll the inked roller over the whole surface. Damp the plate again and repeat until the image has the correct density of ink. Dry with the hair dryer. Note that if the plate is not damp enough, the plate will hold ink in the un-inked areas and scum up; whereas if the plate is too wet, it will cause inky watermarks and not adhere properly. Once you are happy that the plate is at the correct level of wetness, print. Once printed, damp the plate immediately and continue.

If scum occurs, wash off the image with turpentine and roll with press black ink, which is a non-drying ink, and cover with green etch. Have a break and try again later.

To print using an etching press, sponge the press bed with gum arabic and lay the plate on top. Ink the plate and run through the press as for an etching, with very slightly dampened paper and increased pressure.

A plate litho can be cleaned and resensitised as follows several times to allow further colour to be printed.

1. Wearing rubber gloves, wash off the inked image with turps. Remove it from the press bed and take it to a sink. Wrap a rag tightly around a stick to form a good pad. Do not use a scrubbing brush as this will scratch the plate and ruin the surface.

2. To erase an image, place the plate in a large sink or photographic tray, making sure that running water is close at hand. Pour Erasol over the plate and then a small amount of whiting (ground chalk), and work them in firmly together across the surface with a rag on a stick. This will erase the image from the plate. Rinse with water and dry.

3. Mix a solution of ten parts water and one part Prepasol as before, and pour evenly across the surface, letting the mixture run over the whole plate. Rinse with water and dry.

Stone slab and roller

The plate is ready to have the edges gummed with gum arabic, and the next colour applied.

Note that both Erasol and Prepasol should be kept in a metal cabinet.

A slight ghost image will be left on the plate, making registration straightforward when adding another colour. Draw and paint the next colour to be printed. Process the plate as before and prepare to print using the procedure already followed.

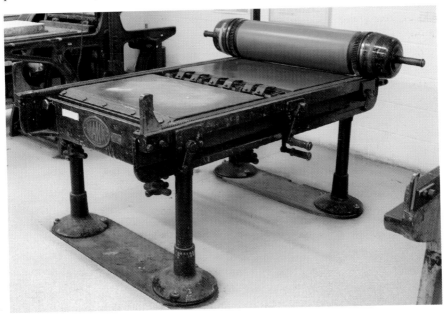

Large litho press, make unknown

LITHOGRAPHY

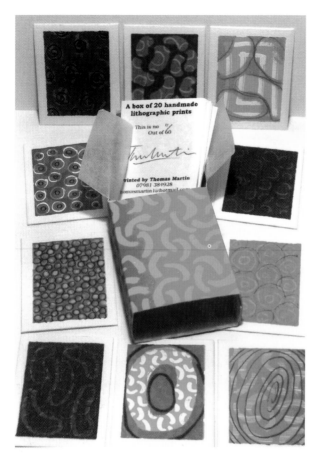

Thomas Martin, *Matchbox*, lithograph monoprints series of 60, 2005

To register the second colour, print onto a sheet of acetate and stick masking tape along the roller edge. Place the first colour print under the acetate sheet, and register. Mark with a permanent marker where the paper should sit, and continue printing. The plate will become less sensitised each time it is erased and prepped; the plate surface becomes less grainy. However, a litho plate can be sent back to the supplier to be reground.

Paper litho prints

Paper litho plates can be purchased from printmaking suppliers. There is a brand from the USA called Litho-sketch Paper Plate. It does not use chemicals and is sold with Litho-sketch Solution. Inexpensive and simple to use, it has an appearance of plate lithography and prints successfully on an etching press. It can also be thrown away after use.

When printing, place the paper on a piece of card before running it through the press, to enable better pressure. Use one paper plate per colour. Follow the instructions for processing as before, and print using etching or relief-printing ink, as this method needs a viscous ink.

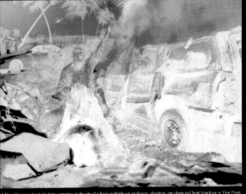

James Greenedark, *The New Dark Times*, 33 × 53cm (13 × 21 in.). Ink jet on newsprint, offset lithography, HTML edition 100 prints front and back. The image is distributed via refurbished newspaper vending boxes which are repainted then vinyl details are applied, the works are then viewed via the web, www.thecoa.org/darktimes

4 SILKSCREEN

This process lends itself well to working on a budget. Innovative original prints can be produced with a minimum of materials, and basic equipment can be made yourself.

Screen-printing is an adaptation of stencil-making. It can be pursued using found and affordable tools and materials, which can be purchased from good-quality art or printmaking suppliers. Alternatively, you can easily make the basic equipment you're going to need. The image is printed using a screen – a wood or metal stretcher onto which a taut synthetic fabric mesh has been stretched. The ink is pulled across and through the mesh onto a sheet of paper or any flat surface. In contemporary screen-printing the ink used is water-based.

The silkscreen process offers an experimental approach, which can be anything from straightforward to complicated. It has the advantage of not printing in reverse.

The following is an introduction to simple stencil-making, which will allow you to have a go at silkscreen-printing, or which you can use in combination with etching, relief or lithography.

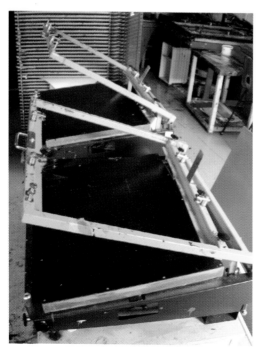

Silkscreen bed with vacuum

Basic equipment

A screen can be obtained from printmaking suppliers, or you can make a frame using wood which is 5 x 5 cm (2 x 2 in.) thick. The size of the frame depends on the space you have available and the size of prints you want. Varnish the wood frame or it will warp.

Take a piece of fine polyester synthetic fabric cut to size (available in both printmaking supply shops and from fabric stores), and stretch this onto the frame as a painter would a canvas. The stretched surface has to be taut throughout, and the inside edge of both mesh and screen need to be completely watertight. Seal with 5 cm (2 in.) parcel tape to stop seepage when printing.

Commercial screen beds can be expensive. However, they are excellent to print from and available in many sizes.

Libby Lloyd, *Robin red breast*, silkscreen, 55 × 76cm (22 × 30 in.)

The advantage is an inbuilt vacuum suction, which helps to achieve an even print. Alternatively, a home-produced version will print well and can be easily put together.

Attach two hinges to one end of the stretcher so that when face down it can simply be screwed onto a wood-board base 5 cm (2 in.) larger than the screen. This will enable stability when printing.

You'll need a squeegee to push the ink through the mesh onto the paper. These are widely available in good art suppliers in a variety of sizes and a choice of blades – hard or soft. Both kinds are required for printing: if the printing paper has a rough surface, a soft blade will help to push the ink through the screen mesh; for fine detail printed onto a smooth paper, use a hard-blade squeegee. The squeegee needs to be 5 cm (2 in.) larger than the area to be printed so that the ink prints smoothly.

Ink

There are two choices of water-based acrylic ink. The first, ideal for beginners, is Rowney System 3, a UK product that has the advantage of not drying too quickly. It is a good printing ink with a wide choice of colours. However, it does give a slightly chalky quality to the print surface.

The second type of ink is a US product called T.W. Graphics. This has the advantage that the colour prints true to how it appears on the tin. However, it dries very quickly and is not recommended to the beginner.

Both inks can be mixed with Daler Rowney acrylic-based medium. Always mix 50% ink with 50% medium.

Alison Spanyol, *Hands On Me*, silkscreen, 120 x 30 cm (47¾ x 11¾ in.), cotton, satin, embroidery, silkscreen

TIP

Daler Rowney acrylic base is versatile and can be mixed with any acrylic paint. Mix using plastic cups, preferably with lids, or cover with cling film to keep fresh.

Note that if the ink is not fresh it will become sticky. Add drops of medium base to return it to the correct consistency of thin double cream. If transparent ink is required, add a lot more base medium. Although water can be added to return the ink to the correct consistency, it has a tendency to dry too quickly during the printing procedure.

Print methods

Screen face up is the smooth side of the screen covered with mesh; screen face down is where the stretcher side faces upwards.

Make sure always to use good-quality parcel or plastic tape. For all silkscreen methods tape up an 8 cm (3¼ in.) margin all the way round from the inside edge of the frame. This enables the correct pressure, or snap, when printing.

Justin Diggle, *Flying Figure 1*, screenprint, monoprint using traditional silkscreen techniques.
63 x 48cm (25 x 19 in.)

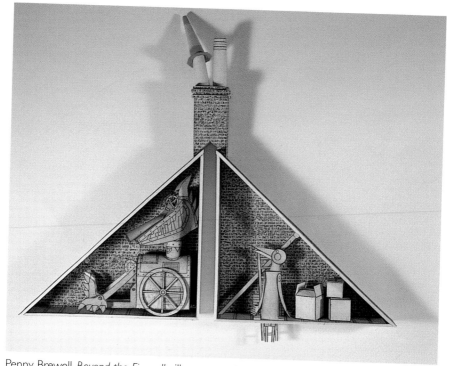

Penny Brewell, *Beyond the Firewall*, silkscreen and etching, 74 × 65cm (29 × 25½ in.), edition size 2, 3D printed construction

Always print using the knife edge of the squeegee and always hold at 45 degrees.

Flood the screen with ink as soon as a print is pulled. Otherwise the ink in the mesh will dry.

Screen-painting

Prepare the screen for printing and mix the colours you plan to print with. Lots of different colours can be applied. Then, with the screen face down, paint the image directly onto the screen. The ink has to be a good thickness.

If you intend there to be a non-printed area on the printed image, paint that area onto the screen with the acrylic base medium. Do not leave any part uncovered with either ink or base medium.

Do not use pressure when painting; no ink should escape through the mesh at this stage. When the image is ready to print, pour a colour or base medium across the top of the screen. Next, place the printing paper into position. Then lower the screen carefully. Hold the squeegee at a 45-degree angle and firmly pull it from top to bottom with even, smooth pressure. Using the squeegee, flood the image with ink from bottom to top.

Anthony Lee, *It's Always This Way*, screenprint, water based, 23 × 34cm (9 × 13½ in.)

Paper stencil

The paper needs to be held in place by the ink and stick to the screen. If the paper is too thick it will just fall off. Blank newspaper is perfect for this technique. It is also cheap and widely available. Ordinary newsprint and sugar paper are both too heavy.

A stencil print can print a run of up to 15 prints. It can also print either as a positive or negative. The stencil paper needs to be 1 cm (⅜ in.) larger all the way round than the printed area of the screen. Working from the centre out, cut the stencil from the paper. Then prepare the screen for printing and have the printing paper ready. Cut a sheet of acetate for registration 10 cm (4 in.) larger all the way round than the printing paper, and attach with tape along the

Teresa Ferrier, *Courting Colours Pink*, silkscreen 20 × 17 cm (8 × 6¾ in.)

bottom of the press bed. Place the stencil on top of the acetate. Pour ink along the bottom of the screen and, using the squeegee blade, flood the ink to the top of the screen.

Lift the screen and the paper stencil will be attached and stuck to the screen face. Pull the screen down onto the acetate and print. Flood the screen with ink, drawing the squeegee from bottom to top. Lift the screen again, and the stencil image will have printed onto the acetate. Place the printing paper under the acetate, keep flat and move the paper to the right position. Then carefully flip the acetate backwards so that it hangs down flat from the press bed.

Place the printing paper on the base of the screen bed.

Cut three pieces of paper, each measuring 3 cm x 6 cm (1⅛ in. x 2⅓ in.). Stick two of these paper tabs down one long side edge of the paper and one along the bottom edge, to form an L-shape.

Mark the printing paper where the corner of the 'L' meets the printing paper corner. This will allow several colours and stencils to print together in registration.

Clean the screen by removing both stencil and ink, and washing it with water using a showerhead, hosepipe or watering can. Then repeat the process using another stencil to build up colour and image.

Simple photo stencil

Degrease the screen using either washing powder or washing-up liquid, water and a soft brush. Rinse and dry. Prepare the image. True Grain is a finely coated plastic paper available through paper and print suppliers. It enables washes, tones, pen and ink as well as linear mark-making materials to transfer onto a screen through a simple photographic transfer.

Have ready a key image. If more than one colour is to be printed, use one sheet per colour. Alternatively, for pen and ink and graphite pencil marks use tracing paper. Another option is to draw the image onto thin cartridge or photocopy paper that has been rubbed gently with vegetable oil and dried. Draw against a light source such as a window. The marks have to be opaque.

Place the screen upright in a photography tray and, in daylight, carefully coat the flat front side of the screen with photo-stencil emulsion using a hard squeegee blade at least 5 cm (2 in.) wider than the image. In a warm dark room, place the image face down onto the surface of the screen and cover with glass or Perspex to keep it flush while it dries. Remember that light will expose it. If a light bulb is the light source, expose for ten minutes if using a 250W bulb or 45 minutes if using a 150W bulb. The image can also be exposed by sunlight, though try a test run first. When hardened and exposed, the emulsion alters colour, so carefully lift the glass and peel back the paper to check.

When exposed, wash both sides with water through a showerhead and the positive image will be revealed. Prepare to print as before.

These methods form the bases of many others within screen-printing. For more details see *Water-based Screenprinting* by Steve Hoskins (London: A&C Black, 2001).

5 PAPER, PAPERMAKING AND PRINTING SURFACES

Paper is a manmade natural material and an instinctive surface for printmakers to use. It is usually grouped into three categories – machine-made, mould-made and handmade – within which is a wealth of versatility.

Selecting paper and alternative printing surfaces is an important part of the printmaking process and can make a lot of difference to the final piece. Collecting different papers can become addictive. Moreover, never throw any piece away, as every little bit acquired can be safely stored for the day when there will be a use for it, or in case of scarcity. Collect anything unusual – found scraps, paper bags, even sweet wrappers – and always save any leftover torn-down paper pieces used in printing.

Although every conceivable type of paper is made somewhere in the world, it is sometimes hard to obtain the one you want. In some countries, paper is made mainly for export, and imported, mould-made, high-content cotton-rag paper can be very expensive. It may be that the only way to obtain this or similar paper is to make it. Luckily, the raw materials and basic equipment are always available.

Paper has existed for many centuries, and although it has been developed, changed and refined, the same basic straightforward recipe still applies. The results, however, are always unique.

Paper terminology

- *Deckle edge* (the feathered edge on all four sides of a handmade sheet of paper)
- *Size* (water-resistant substance that can be added to paper when it is being made, or painted onto it once it is dry)
- *Waterleaf* (unsized paper)
- *H.P.* or *hot-pressed paper* (a smooth and slightly glossy paper with a hard surface, made by pressing between hot metal sheets through a wringer or press)
- *Not* (the name given to mould-made or handmade paper which has not been hot-pressed, just dried under pressure. It is halfway between the smooth and rough surface.)

Andrew Curtis, *Postcard* series, monoprinting, typography, photo techniques, 16.7 x 23.5 cm (6½ x 9 in.). Edition 49, hand printed postcards, sent every Monday since 18/10/04 to artists, galleries, Universities, incorporating own and other artists work. Emphasis on sharing and collaboration.

Machine-made paper

Machine-made paper is often taken for granted. It is manufactured inexpensively and widely available, in some form or other, even if the choice is extremely limited. Nearly everything we buy is packaged or wrapped in some way with machine-made paper. Cardboard boxes, paper bags, envelopes, writing paper, cheap notebooks can all be saved for use as printing paper. It may not be good quality, but with a little imagination it can be used to great effect.

One paper universally manufactured is cartridge paper. It is generally available in bright white, is smooth and has no surface texture. This everyday run-of-the-mill paper has hidden qualities. It can be altered very simply into fine handmade paper with a naturally deckled, feathered edge. It can be dyed, peeled, sanded, washed with watercolour and painted prior to printing. Once turned into pulp, it can be made into paper of any size, shape or thickness. It can be given an even or rough surface. Plant fibres, petals, leaves, small torn scraps of paper and cotton threads can be mixed into the recycled paper pulp, transforming it into unusual and original sheets of paper.

Sugar paper is another widely available paper and the cheapest of all machine-made papers. A soft, coloured paper, it is good for hand-printing.

There are lots of other machine-made papers. They come in a wide range of sizes and gram weights. They vary tremendously in price and availability. It is always well worth checking any art supply or stationery shop to see the extent

Mandy Bonnell, *Lighthouse*, 56 × 76 cm (22½ × 30 in.). Etching and chine collé on Japanese paper

of the available range. There are often surprises.

Some papers to look out for are tracing paper, any tissue papers (especially the photographic ones), lens tissue, glassine (a translucent paper with a gloss finish the colour of pale amber), and vegetable parchment.

Mould-made paper

Mould-made papers are good-quality papers. Manufactured in rolls on a machine using a high percentage of cotton rag, they are often mistaken for handmade papers, as with two deckle edges they appear very similar. There are three different surfaces with mould-made papers: H.P. (hot-pressed), Not, and Rough. They are made in several gram weights and a variety of sizes. The colours are natural and minimal: bright cool whites, warm whites, creams, tan and black. All are acid-free.

Printmaking papers are internally sized, meaning that the size has been mixed in with the pulp material before the paper has been pulled from the vat.

Mould-made papers are produced by Arches, B.F.K. Rives, Fabriano, Somerset, Hannemuller and Zirkall.

Handmade paper

Handmade paper is distinctive. Each sheet has its own individuality. The surface, texture, thickness and natural deckle edges are unique.

There are specialist paper mills around the world producing handmade paper. A lot is exported and the price range is diverse. European and American handmade paper mills produce paper using 100% cotton rag. Indian and Nepalese papers are made from cotton and plant fibres such as hemp, banana, bagasse, tea and sisal. Their natural colours range from ivory to amber. Rag-made papers are produced in various weights and sizes in natural and dyed colours of emerald, ruby, earth red, sand and sapphire.

ABOVE Anne-Marie Foster,
*Redwhiteblueblackyellowcafe-au-
laitpeaches&creamolivegreen*,
screenprint, monoprint with pasted
paper, pencil, bleach, 153 × 102 cm (60
× 40 in.)

Nick Devison, *Cruciforms*, carborundum.
The image was screen printed onto
mount card using a slow-drying acrylic
medium. Fine carborundum powder
was shaken over the card whilst the
medium was still wet. The powder was
then shaken off, adhering only to the
screenprinted areas. The card was then
sealed with an acrylic varnish prior to
inking up. Inking the card was carried
out both as traditional intaglio and as
relief 'roll-up' in order to create a
negative image.

Timo Lehtonen, *Lafroda I V*, relief print, diffused ink and graphite, 56 × 76cm (22½ × 30 in.)

Japanese paper recipes have been handed down through many centuries. These papers are made in limited and unrepeated editions. They range in weight, translucency and finish. Each new group is different. There are also decorative papers from Japan, Thailand and Korea, such as ornamental tissue paper and wafer-thin lace paper in every conceivable colour.

Paper grain and weight

All paper can be used and printed on both sides, but there are lots of papers which have a right side. With handmade or mould-made paper, the right side is easy to recognize, as when the paper is held up to the light the make of the paper can be seen as a watermark. Inexpensive, machine-made papers have no watermark.

All paper has a grain, which means that the paper fibres follow a specific direction. Hand-made papers can be difficult to fold, as the grain fabrication travels in different directions, leading to creases in the folded edge. Mould-made papers are produced on a machine in great lengths, which are then cut down to standard sizes. The grain usually runs along the length of the paper. Test before making a permanent, creased fold by gently folding it over lengthwise so that the two short ends touch each other. If there is 'bounce' when touching the surface, then this is the direction of the grain. If there is no give or bounce in the surface, the grain direction will be running across the width of the paper. Paper folded against the grain can be damaged or creased.

The weight or thickness of the paper also needs to be considered. Paper is

weighed by gram weight. A lightweight cartridge manufactured paper is approximately 40–60 gsm (gram weight). Mould-made papers can weigh anywhere from that light weight up to 600 gsm, which is a visibly very heavyweight paper. A smooth mould-made paper such as Fabriano Artistico in a gram weight of 200 gsm H.P. will fold and cut with ease.

Paper finishes

When paper is in short supply and the choice is limited, it can always be made more interesting. Paper is strong and can withstand damage such as bruising and distressing. There are several ways to distress or bruise a sheet of paper. The paper can be screwed up and placed in a bucket of water, left to soak and then carefully squeezed until it is no longer dripping with water. Gently unfold the paper and lay it flat to dry. It can then be lightly coloured with watercolour. The result is a frail, veined subtle pattern. This works well using cartridge paper.

Andrew Folan, *The Sleep of Reason*, (after Goya), etching, 26 × 20 × 10 cm (10¼ × 8 × 4 in.), unique stack of 100 etchings

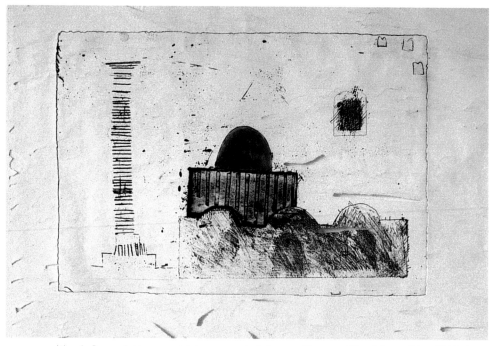

Mandy Bonnell, *Mosque*, etching on peeled distressed paper, 76 × 56 cm (30 × 22½ in.)

Paper can take a lot of aggression. Medium and coarse sandpaper leaves effective textures, which can then be water-coloured prior to printing.

Peeling damp paper, either a whole sheet or just a part of it, is very effective. This method needs a heavier-weight paper or card. Dampen the paper lightly with water and leave so that the paper becomes soft. Starting at one end and using a sharp knife or scalpel, lift a thin layer of paper from the surface. Not all the paper will peel away in one go, and as such it may form a broken surface pattern; peeling paper reveals textures, shapes and patterns. The paper can be lightly dyed or painted with a watercolour wash. The colour needs to be subtle or the textured finish will be lost.

Papermaking

Making paper is not difficult, but it does take practice, perseverance and time to make good, even sheets. There are always the raw materials available to make paper – any recycled scrap papers, or printing paper offcuts. The aim is to produce good-quality paper for personal use, to print and enhance an image.

Producing a sheet of paper is always the same procedure. There are two main things to remember. One is to beat the pulp until it really is a mushy mass, and the other is to make sure that the water used throughout the process is free of impurities. The mushy, water-saturated mass will be transformed into flat paper sheets.

Mould and deckle

Traditionally the mould and deckle are equal size. Make two wooden frames the same size. Varnish the wood to protect it from warping and to strengthen the corners. Cover one side of one frame with a very fine plastic-wire gauze mesh. The stretched gauze has to remain mobile and flat, and needs to be fixed with tacks or nails to the frame. This is the mould. The other frame forms the deckle. Keep the mould mesh facing upwards and place the deckle on top.

TIP

To save money, artist James Mbuthia in Kenya made a mould and deckle A1 in size. He also made two smaller deckles that enabled him to produce different size paper sheets economically.

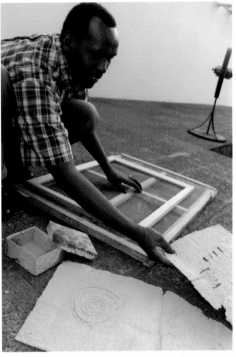

Mould and deckle

Making paper from recycled paper

You'll need a plastic or metal bucket, scissors, a large plastic sieve, a large wooden spoon or stick, a cooking pot, a small electric ring, and water. Collect enough paper scraps and tear or cut them into half-inch pieces. Fill a bucket to approximately two-thirds, cover completely with hot water, and leave to soak overnight.

Next day, the paper pieces can be boiled using fresh water for 20–30 minutes, so that the resulting paper pieces become very soggy to touch and the starch or size has been removed. The water that the paper has been soaked in will be discoloured and slimy. Drain the paper pieces through a sieve and squeeze out the excess water by hand. If the paper is very soft, it is ready for beating; if it is not, soak it again in fresh water and then reboil.

For beating the paper you will need a large flat chopping board or concrete slab, a plastic measuring jug, plastic or glass jars with lids, a pestle and mortar, a large wooden mallet, a hammer, an electric blender, a bucket, and a sieve.

Place the very soft, squeezed paper pieces evenly onto the slab. Using a grinding, chopping action, start to amalgamate the paper with a pestle or mallet so that it becomes an even, sloppy mass. Regularly sprinkle it with water to keep the paper mass mushy. To check that the pulp is ready, put a spoonful of the mixture into a clear plastic jar filled with water, and shake. When there are no visible signs of paper pieces and the mixture is even and cloudy, the pulp is ready.

Alternatively, mix the paper pieces vigorously in an electric blender to hasten the process. Start with a small spoonful of the pre-ground, softened paper pieces, blended with plenty of water and whizzed until the water becomes cloudy. Gradually add more of the paper pieces and repeat until all the pieces have been mixed.

Producing paper sheets

For this you will need a mould and deckle, sponges, a plastic bucket, a sieve, cotton sheeting cut to size, plastic sheeting, a very large tin bath or a plastic baby bath, wooden boards for drying, an electric iron, and newsprint.

Fill the container with fresh water. Allow as much space as possible, and have everything ready.

The water and pulp mixture needs to be the consistency of thin cream. Stir the pulp so that the mixture is well blended. Then, holding the mould and deckle firmly together by the short sides, place them into the water mixture and lift them out again, carefully and horizontally. Allow the water to drain back into the bath. Then lift the deckle away from the mould. The flat pulp should be spread evenly across the mould. If it is not, start again.

If thin sheets are required, leave off the deckle when pulling the paper sheets. The paper edge will be thin and deckled – yes, a deckled edge is what you get when you don't use a deckle!

There are two ways to dry the paper: air-drying and couching.

Couching

With this drying method, the paper sheets emerge with a slightly smoother finish. You'll need a single mould and deckle. The paper sheets are made in exactly the same way, with the sole difference that the paper is removed from the frame after each sheet has been produced.

Dip the mould and deckle together into the water bath and drain the excess water as above. Carefully lift the deckle from the mould and turn the mould, with paper attached, onto a wad of newspaper which has been covered with a piece of cotton sheeting. Using a sponge, very carefully press any excess water from the inside of the mould. Then lift the mould very gently away from the wet paper, and cover the paper with cotton sheeting. The paper-pulped sheets can be piled on top of each other, layering a piece of cotton sheeting between each newly made paper piece. When you have finished making sheets, lay the pile of paper between wooden boards and cover with a heavy weight. The cotton sheets laid between the new paper sheets need to be changed daily, or the paper sheets need to be hung on pegs to dry. To obtain a smooth paper, press with a hot iron through a cotton sheet.

Air-dry

With this method, the paper is left on the frame to dry. Remember that paper left in the sun will fade, as sunlight acts as a natural bleach. Dry flat. When the

paper is completely dry, remove it from the frame by inserting a knife at one edge and very carefully peeling the paper away from the surface. Several deckles will be needed, as one deckle equals one sheet.

Sizing

Size is a glutinous substance that strengthens paper. Rice paste, starch and water-based paper glue are all size agents. Printmaking papers are sized internally. This is to keep the paper soft and malleable during printing, and is done by mixing the size or glue with the water at the pulping stage, at a ratio of four measures of size to four of pulp.

Paper can also be sized externally, which means that once the paper is produced and dried, it can be dipped into a weak water-and-size solution.

Bleaching

Bleaching lightens the colour of paper. If the paper is a very dull grey or brown colour it can benefit from being lightened a little. The most natural way to lighten paper is by exposing it to sunlight.

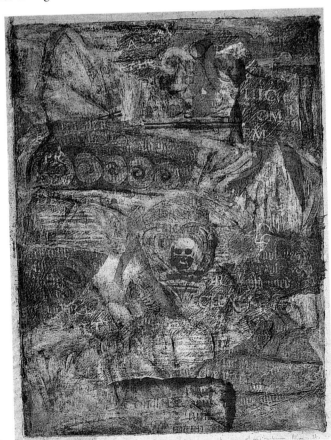

Jackie Newell, *Graven Fragments*, chine collé of torn litho images and collaged onto Indian Khadi paper, 56 × 76cm (22½ × 30 in.)

6 PACKAGING

A sheet of paper folded in half becomes a card. Writing inside the card and addressing it to a friend transforms the card into a personal package containing information. This uncomplicated, effortless action is the most straightforward package to produce.

By its very nature packaging is always being handled. Opening parcels, packets and envelopes is something we take for granted. In our eagerness to find what's inside, we hardly notice most of the packaging we handle in our daily lives. But functional packaging and paper can become an individual printed artwork that will give pleasure in its own right.

Lots of art materials are expensive, so it is well worth collecting and keeping everyday packets that catch your eye to use later as a surface to print onto, to stencil, cut or collage, or as a means of storing materials or protecting prints, keeping them clean and flat.

As well as its usual function, packaging can be turned to more surprising ends. A sketchbook using an assortment of papers that have different weights and textures can be made from disused packets, paper bags or offcuts of papers left over from printing. Functional utility papers such as tracing paper, newsprint, greaseproof paper and brown paper can be transformed into a simply produced sketchpad by clipping, stapling, paper-punching and tying.

Brown tie labels make an excellent small sketchbook or artist's book just by stringing them together through the existing punched hole. These labels have a smooth surface that is good for drawing or printing.

Two pieces of heavy card, mounting board or corrugated paper stuck together across one long edge with parcel tape, carpet tape or masking tape make an easy and inexpensive portfolio. A string handle could be attached, and the two short sides could also be punched with a puncher and tied together with ribbon or string. Taking this idea as a starting point, there are lots of possibilities to pursue. Look at the range of portfolios available in art supply shops. Notice how straight-forward they are to make. With minor modifications, you can make your own.

Exhibition invitation cards can be hand-printed to save on exhibition costs, while posters and leaflets can be printed, rolled and folded. To make your own envelopes or packets, carefully unfold used ones to provide you with a natural template.

Assemblages

This approach can include working with readymade materials, installations and packaging, either found or made. It has an affinity with visual narrative imagery and the written word. For an idea of what is possible, look at the work

of
the
Dada

Susan Withers, *Germ Light; Lobe*, 14 cm (6¼ in.) diameter, mixed media: ink, light unit. They are intended to be simultaneously seductive and repellent, an evocation of both beauty and disgust. While they glow invitingly they allude to the untouchable, but as the on/off switch is contained within each light, it is necessary to touch the Germ Light to view the image

movement and artists such as Eduardo Paolozzi, Peter Blake and Joseph Cornell.

Artist Susan Withers's unique series of 12 different editioned *Germ Light* prints makes very good use of working with readymade, inexpensive lighting, which she delicately and selectively worked over the surface of a plastic lightshade with etching ink. The lights were available individually in specially hand-printed boxes, and exhibited as an installation at The Wellcome Trust.

Following on from this, in collaboration with artist Andrew Moller she produced *Commemorative Stamp*, which included a rubber stamp, an inkpad and a printed instruction leaflet. The piece actively encourages interactivity as a means of viewing and appreciating the work.

Artist Gill Bradley has combined found materials and digital printing within a handmade box, while Alison Bracy has incorporated printed paper-engineering techniques within her installation *A Place to Dream*. Finally, Jonathon Narachinron has used traditional screen-printing and digital printing with paper engineering to produce his large installations of fruit.

Gill Bradley, *My Bleating Heart*, digital A3, 3D box frame, digital print, plastic sheep and bleat boxes. Bleating sound triggered by turning image 180 degrees

Simple paper construction

Paper construction is about creating and exploring new ideas by taking a flat sheet of paper and transforming it into a three-dimensional object. The tools and materials are minimal: a cutting mat, a scalpel and blades, a ruler, a set square, and a bone folder shoe or paper knife. You only need the surface of a table to start to produce simple shapes and objects.

ABOVE Susan Withers and Andrew Moller, *Commemorative Stamp*, printmaking technique. A rubber stamp as intervention, boxed stamp 90 × 160 mm (3½ × 6⅓ in.), mixed media. A rubber stamp, boxed with ink pad and instructions

RIGHT Alison Bracy, *A Place to Dream*, installation, screenprint on Japanese paper, paper engineered part of installation. House 29 × 21 × 16 cm (11¼ × 8½ ×6⅓ in.), church 45.5 × 23 × 30 cm (17¾ × 9 ×11¾ in.)

Folding

Try out and practise different ways of folding to create a leaflet, an envelope or a concertina. Use simple origami-style folds and folding out, i.e. a page folded inside a book, leaflet or brochure doubling in size when opened.

Corresponding folds have a parallel cut added and are used to create pop-ups. A simple and straightforward pop-up is to fold a piece of paper in half, cut twice at right angles, and between the two cuts fold in reverse.

Cutting

Cutting, ripping and strategically tearing paper can be used to create

lots of different and interesting effects. A cut slit can be used and shaped to attach a page or to insert a printed label, or it can used to slot paper pieces or cards together to make shapes. If two pieces of paper are placed on top of each other, the top piece carefully torn could be used to expose a selected printed area or image underneath. Different cut stencil-printed shapes can be used to great effect by working in this way.

These ideas are just starting points. With practice, so much more can be achieved and developed.

LEFT Jonathon Narachinron, *Small Nara Melon*, sculpture, large variable size, screen print, digital

BELOW Mustafa Sidki, *Inter Active Card*, digital print outs, 21cm x 9.9cm (8½ x 4 in.), taken from ink drawings, Somerset 300gsm

ABOVE AND BELOW Stephen Mumberson, from his toy collection. The toys are produced from used found metal food containers.

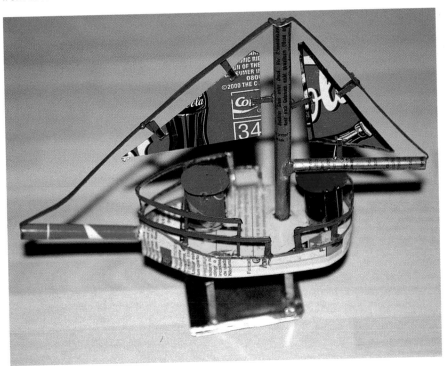

7 SIMPLE ARTISTS' BOOKS

There is not really a definitive form for an artist's book, but invariably it resembles a traditional book, while at the same time seeking to push at the boundaries of what a book can be. Artists' books are designed by the artists who make them; they can be produced as multiples or as unique pieces of work.

This chapter introduces a few simple ideas for working within this medium. It will focus on producing books for which a minimum of easily acquired materials and equipment are needed. The emphasis is on looking simply and creatively at book production through the techniques of gluing, sticking, folding, rolling, stapling, knotting, tying, clipping, bolting and manipulating.

Think about how a book can best represent the images contained within it. A book lends itself naturally to addressing a specific moment in time and movement in space: there are natural pauses between pages as well as a continuous visual narrative.

A book will automatically draw whoever is viewing it into experiencing the texture of a page as they turn it over to read the next image or piece of text. Books encourage interaction by touch and feel. The content and the structure need to complement each other, and the design of the book needs equal consideration. Because of its physical presence a book can be seen as a sculptural form.

Shops selling stationery are an invaluable resource for paper attachments, as well as allowing the chance to look at how the cheapest notepads have been put together. A plastic casing that could be collaged, printed upon or cut into can make a very original cover for a book. Ring binders can be another form of attachment. Schoolbooks where the page folds have been stapled together can be easily utilised or made. There is a wide variety of paper clips, staples and drawing pins available, all in various sizes and colours. All of these could be used or incorporated to form bindings and attachments. Moreover, haberdashery departments are a good source of ribbons, trimmings, tassels, buttons, poppers, and hooks and eyes; also hardware shops for nuts, bolts, screws, nails, string, twine and wire.

The equipment needed to produce an artist's book is minimal: a bone folder for folding, a shoe knife and a scalpel for cutting, a cutting mat, a ruler, a pair of scissors, a rubber, a hard, sharp pencil and a water-paste glue. Pritt Stick is ideal, being a dry glue that is also acid-free.

Once decisions have been made regarding the preliminary drawings, various book mock-ups need to be produced. Nothing need be set in stone at this stage, but the images and book structure need to evolve together. A mock-up can be produced from newsprint, and like the preliminary drawings, is a working model to help with resolving the finished piece. As when producing the actual prints, start to fine-tune the paper structure by experimenting with different

types of paper or card. Spend time just folding and trying out differing combinations of image placement and paper. Consider the order, sequence and narrative of the images while folding and making the mock-up.

There is always a point while making a book when the initial idea starts to evolve naturally, and at this point the book itself seems to dictate how it will be completed. For the artist, making a book is a personal journey of discovery.

Simple book ideas to try

Any print process or combination print could be used for these easy-to-make but effective books.

Flip books

A flip book can be produced very simply. A good-quality, smooth, mould-made paper at 200 gsm is ideal, as the book will flick smoothly without being ruined. The paper is cut to exactly the same size and the images are stacked together in order.

A simple paper clip is very effective in holding the book together.

RIGHT AND BELOW Mandy Bonnell, *ANTMOTHBEETLEMILLIPEDESPIDER*, etching and hand set typography, digital cover, 35 × 35cm (13¾ × 13¾ in.)

ABOVE AND BELOW Mandy Bonnell, *The Second Life of Shells*, etching and chine collé, lino cut end papers, cover and slip case, hand set and printed type, 32 × 23cm (12½ × 9 in.)

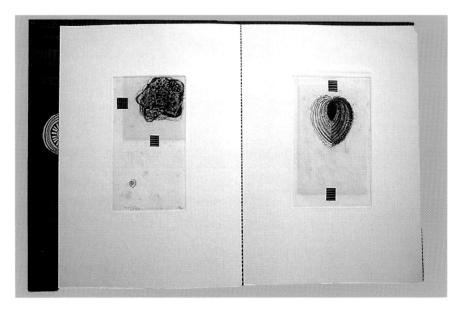

Matchbox books

Cut a length of paper to the dimensions of the matchbox, which itself can be of any size. Both sides of the paper could hold a continuous printed image. Using the bone folder to give a clean, crisp edge, fold the paper to fit the width of the box. The box cover could be covered and printed, or painted over, or covered with a motif which reflects the contents. The matches could also be printed and

placed back in the box, and the box then covered and printed.

Tipped in

This method involves attaching a print to a found book or to a handmade book produced using a different method. Much could be made of the attaching. The print could be attached with a button using a stitch, or, as in some photo albums, a small cut could be made in the book for the corner edges of the print to slip through.

Bolted books

Have a look at photo albums to get an idea of how one of these books can work. Holes could be punched with a puncher to enable some sort of attachment. This could be a solid, hard attachment such as a bolted screw, or it could be a soft material such as ribbon, string, wire or twine. A heavy card could be attached front and back for the cover. There are endless possibilities. A book can be wrapped with a specially printed paper, and tied with string, wire or ribbon, or it can be left in its simplest form with a small wire attachment, to give it an air of mystery prior to opening.

ABOVE AND BELOW Duncan Bullen, *Silence and Light*, artists' book, etching and aquatint, 26 × 26cm (10¼ × 10¼ in.)

Scroll

A scroll is a continuous roll of paper that can be printed onto to form a book. It can be tied or closed with ribbon or with a button. A roll of wallpaper or lining paper is an inexpensive way of making a long scroll.

Altering books by manipulation

Second-hand shops often stock old books and paperbacks. Taking a used book and reappropriating it by cutting into it or printing over it may feel a strange

David Ferry, *A Picture History of England... mainly in black and white.*
Lithography, letterpress, 21 × 30cm (8¼ × 11¾ in.).

thing to do, but altering a book that has otherwise been discarded allows it another chance to be seen and read, albeit in a different way.

The book can be cut into or printed onto; whole sections could be cut out altogether. A book can be carefully ripped and strategically torn, collaged from found materials or printed pieces, sewn through, nailed into, pin-pricked, stuck together or completely hollowed out, with new prints attached as a concertina. There are lots of possibilities.

Artist David Ferry has been manipulating books for many years. He has even produced an alternative library of manipulated books, all of which

are unique and exquisite, carefully and meticulously put together using photomontage.

Found covers, end papers and materials

To make a cover for a book could be as simple as wrapping a heavier-weight paper around the pages and tying with ribbon. To take this a little further, the cover could be specially printed, which can add an extra dimension to the sculptural object. A cover can define a book, so it is an important element when considering the concept and design. Covers can be found and printed over. As an example, if a book is based on correspondence a large used envelope could be used as a casing to contain the book. Alternatively, if a book is about

colour the predominant colour could be used on the cover. The cover could be produced from found fabric and stitched into, it could be knitted or felted, or it could be as simple as an interesting found box – whether tin, wood or cardboard, it could be just the right thing if it suits the contents. Look for offcuts of thin plywood, aluminium or Perspex, as these could be screenprinted or relief-printed, and bolted or screwed to form a cover.

Joanna Hoffman, *Cardiocord*, paper, rubber stamp, 15 × 21cm (6 × 8¼ in.)

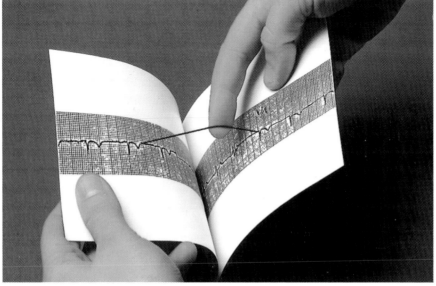

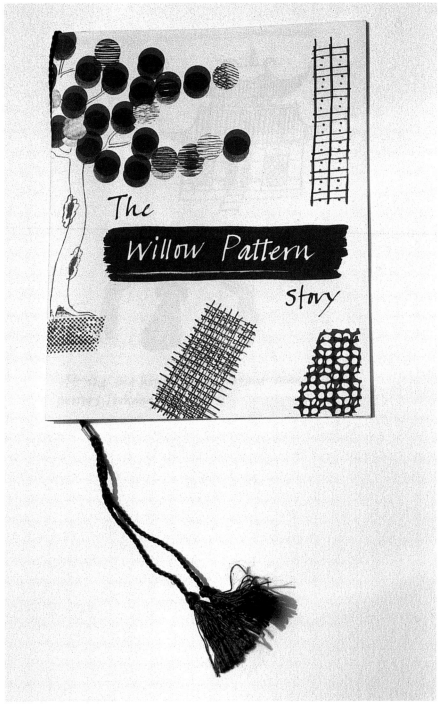

Laura Knight, *The Willow Pattern Story*, book cover, printed by James Spalding UK photo litho, 19 × 30 cm (7¾ × 11¾ in.)

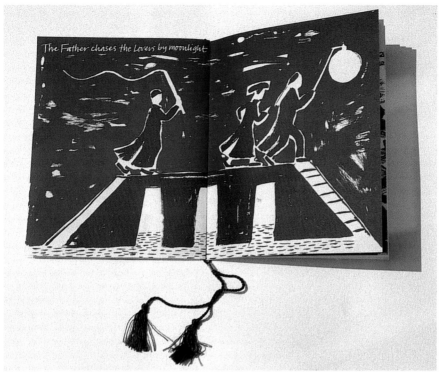

The Father chases the Lovers by moonlight

Laura Knight, *The Willow Pattern Story*, book pages

Corrugated paper, brown parcel paper – there is an endless list that could be successfully used to produce book covers and end papers.

End paper

An end paper is the paper that completely covers the inside of a cloth-covered hardback book and secures the body of the book to its casing or covers. These papers can be marbled, hand-printed, patterned or plain. The paper needs to be strong and should not weigh more than 200 gsm, which is a medium-weight paper.

Concertina

The easiest way to produce a concertina book is to print the images on separate sheets of paper and attach them together after they are printed. As with all book production it is highly recommended that you produce a book mock-up.

There are two types of concertina books to try. One has no spine but has paper-covered boards to attach the accordion-type book. The other has a central spine to which the concertina papers are attached.

Concertina books produced from one continuous sheet of paper are also known as Leporellos. The name comes from the opera *Don Giovanni* by Mozart, in which the main character's servant, Leporello, keeps a book

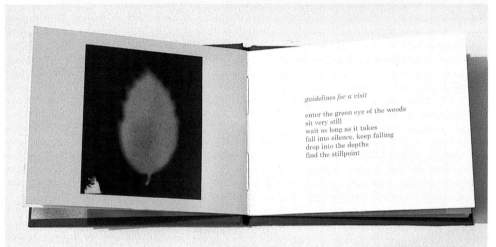

guidelines for a visit

enter the green eye of the woods
sit very still
wait as long as it takes
fall into silence, keep falling
drop into the depths
find the stillpoint

Penny Grist, artists' book, *Hestercombe Genius Loci, Cyanotypes*, 11.5 × 10.5cm (4½ × 4 in.). Limited edition book produced as part of the Genius Loci Project. Text Roselle Angwin.

detailing all his master's many conquests, comprised of a long concertina sheet of paper.

If this is the first time you have made one of these books, start on the accordion book with paper-covered boards. When cutting paper to exactly the same size, cut a template with acetate, as this will help you to cut accurately. If every sheet is 1 mm out of alignment and the book has many pages, it will slope at a noticeably odd angle.

A concertina book can either be turned by the page or it can stand up and be viewed as one continuous piece of work. A good tip is to use only a mould-

made paper that is 100% cotton rag and 200 gsm weight. If the book is to be seen standing and a wood-fibre paper has been used it will curl. Fabriano Artistico H.P. surface is excellent.

To attach the papers to form the book, you will need a bone folder, a scalpel, a ruler and good-quality glue (either rice paste or Pritt Stick is fine). Have ready a lightweight acid-free paper to cut the guards, which are strips of paper cut to approximately 20 cm (8 in.) in width and the exact length of the book pages. Japanese conservation paper is recommended, though a lightweight smooth paper at 60–100 gsm will also work. The paper strips are used to join the printing paper together, to form the concertina.

Have ready a clean dry table or workbench and have all your materials ready at hand. Stack the book pages neatly ready to be glued.

Place two adjoining prints face down next to each other approximately 2 mm apart. Glue evenly one side of the paper strips and carefully and firmly, using the bone folder for pressure, place the strip glue-side down onto the two sheets of paper. This will take a while to dry. Carefully fold back each adjoining print onto its neighbour and continue until all the printed pages are attached. Allow to dry completely under weighted boards – meaning overnight at least.

A concertina book can be exhibited as a complete exhibition of work by opening it out and placing it on a shelf. It resolves framing costs and is easy to transport for travelling exhibitions and showing abroad.

There are many other ways to produce books and lots of other bookbinding techniques. For further reading and detailed description on making books we would recommend *Creating Artists' Books* by Sarah Bodman (London: A&C Black, 2005 and 2007).

8 PRINTMAKING USING FOUND MATERIALS

Combining everyday materials that originally had another use with traditional printmaking techniques can lead to some very innovative prints. This is an area within printmaking which should not be overlooked, as there are lots of possibilities to try, while at the same time costs can be kept to a minimum.

Drawing to produce prints using found implements

Look for alternative ways to produce a mark. Put together a box and fill it with a variety of things that you think would make an interesting mark. At this stage do not think about printmaking processes, just anything that is used on an everyday basis. Materials and alternative implements do not necessarily all have to be sharp. Begin in the morning and continue collecting throughout the day. For example, any or all of the following will be useful: toothbrush, nail brush, sponge, cotton-wool buds, scouring pad, tea towel, knives, forks, spoons, cotton fabrics, fabric trimmings, lace, ribbon, wool, threads, sewing, needles, knitting needles, wire wool, sandpaper, paper towels, masking tape, Sellotape, parcel tape, string, wire, garden twine, nails, screws, scalpel, glue, glue sticks, sand, varnish, sticks, twigs, feathers, leaves – any of these things can either be used to produce a mark on a surface, or can become the drawn image.

Roll a thin, even layer of ink onto a piece of glass, Perspex or aluminium, and using one of the objects listed above – a paper towel, a piece of cloth, a leaf or perhaps a feather –press it into the inky surface to produce an imprint. A thin, smooth paper laid over this and evenly rubbed will produce a print. Layers can be built up and pushed back, or drawn into using a mixture of a toothbrush and wire wool, and areas can be rubbed away or worked or drawn into using a small piece of cloth or a cotton-wool bud or just a stick. If an aluminium plate forms the base surface, it can be printed through a press.

These prints cannot be produced in large numbers, and are often regarded as monoprints. However, prints or sections of prints produced in this way can be incorporated with other printmaking processes and used as collage or chine collé to lend tone or texture to an area of colour.

An aluminium metal surface can be scratched and scored and hammered into with a nail and printed either as a surface roll or in intaglio. When the prints are dry they can be cut into or sanded onto, or hand-coloured, or cut up and collaged into another print. Allow yourself to experiment, as there are endless possibilities for working in this way.

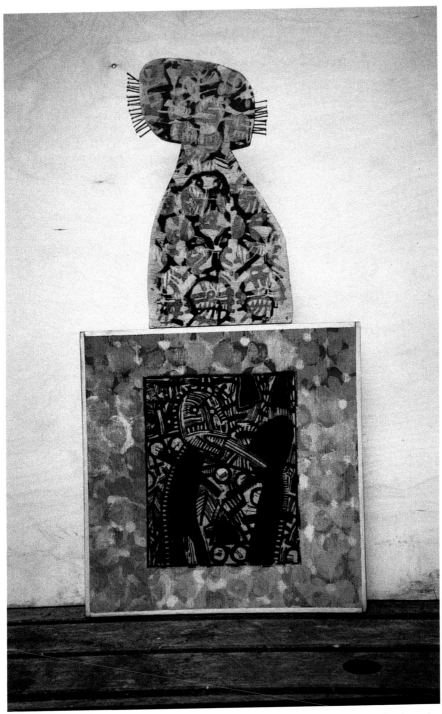

Colin Gillespie, *Memory*, relief and stamp print onto wood with assemblage, mixed media, unique print, 53 × 28 cm (21 × 11 in.)

Jo Love, *Catch Me as I Fall*, dry point and digital print, 180 × 90cm (71 × 35½ in.). Unique print

Collagraph

This process is inventive and uses found materials as its base. A collagraph comprises a collage of textures and materials fixed to a metal or card surface. The process is most successful when the surface is kept low and even. It is very tempting to get carried away with an assortment of materials all at differing heights, placing far too many things on top of each other. Remember that less says more, and can offer subtle variations and gradations, to be built upon by printing a second plate or by working into the plate surface once a proof has been taken.

Masking tape, parcel tape and Sellotape work extremely well. As tape is very thin, several pieces can be overlaid onto each other, and using a scalpel areas can be cut in stencil fashion to produce an image. If the base surface is a heavy card, a thin layer could be peeled away to give different but very successful effects.

The card will begin to break down after a couple of prints. To help prevent this, a thin layer of PVA glue could be painted over the surface. If PVA is used do not print using damp paper, as the glue will dissolve and the print will get stuck.

An alternative would be to seal the card with shellac or a clear varnish. When working with card allow the ink to dry overnight before applying another colour. Emulsion painted onto a heavy card or aluminium plate can also give a very painterly effect.

Collagraphs can be made using discarded packaging, card, paper bags, tin foil or paper stencils. All can be printed in relief and intaglio. When printing in intaglio, if a water-based glue has been used to stick the materials to the surface base, do not dampen the paper.

Fabric can be glued to a base with water-based glue and then coated with Shellac or button polish or yachting varnish. Artist Liz Rideal has produced a

series of elegant prints from a sari, where she used a series of folds and colours. These were printed through an etching press on Japanese paper.

Frottage

Also known as 'rubbing' (from the French word *frotter*, meaning 'to rub'), frottage is a simple and straightforward technique. It can be used to great effect in its own right as well as combining with other printmaking techniques, where it can give a fresh dimension to an image. It is often used while working on a woodblock or plate to enable you to see how the cut image is progressing.

A thin, lightweight, smooth paper is required. A Japanese conservation paper or Nepalese tissue paper is ideal, though a paper bag, wrapping paper or an envelope will work just as effectively. A graphite stick or very soft pencil is all that is needed to produce an image with this technique.

Lay the paper over a surface that has a texture. This could be a piece of driftwood, a floorboard that contains interesting marks, a coarse-weave fabric, or a previous print that you intend to collage and combine with another printed process or to print over. Artist Timo Lehtonen has developed this combination technique in his prints.

Carol Hensher, *Anatomy Lesson*, lithograph on fabric, mounted onto a child sized display dummy. Cloth, fibre glass and metal. 58 × 28cm (22¾ × 11 in.)

Found materials to print onto

Printing on good-quality hand- or mould-made paper is the traditional means of transferring an image onto a surface to produce a print. However, there are lots of other materials to try. For example, all traditional printmaking techniques print very well on fabric. Cotton or canvas either primed or left in its natural state successfully prints all processes. When the print is dry the

Ben Magid, *Shaking hands*, silksreen and digital, 20.5 × 22.5cm (8 × 9 in.)

canvas can be pulled taut on stretchers. If you're printing in intaglio, damp one side with a sponge 30 minutes prior to printing. The printed canvas could become a combination of print and paint, or could use the print as a starting point, or be left as it is.

Relief and silkscreen prints can be very successfully printed on any number of surfaces. Discarded clothing can either become a printed image or be cut and reappropriated. There are also lots of plastic materials to try – plastic bags, bubble wrap, plastic sleeves for folders, flip-flops, and so on. If there is text or an image on the plastic, it could either be incorporated into the new image or printed over; or it could just be cut out and another piece of plastic or paper glued over it.

Wood, metal, CDs, leather, plaster can all be very successfully printed. Make use of utility papers, stationery, envelopes, notepads and labels. Collect bus tickets, till receipts and sweet wrappers. Adopt an open-minded policy to keeping any found papers you think might be later incorporated into a print or printed upon.

Liz Rideal, *Sari*, monotype unique print, inked sari laid directly onto prepared/printed Japanese washi paper run directly through etching press. 1 × 4.5 m (39½ × 177 in.)

Site-specific prints

A shadow could be seen as monoprint. With this in mind, projection can be viewed as a unique print in its own right. The projected space itself becomes the printed artwork, and the projected image is the print. This could be a digitally produced image or a photograph, or a projected drawing, or an image taken from a traditional print process. The image could then be enlarged against a building or a gallery wall.

A wood engraving, which by its nature is usually very small, could be enlarged digitally and projected; or a large image could be shrunk to fit a small space. In 2003, Artist Hilary Paynter completed a series of small wood engravings for Newcastle Central

Hilary Paynter, *From the Rivers to the Sea* series, *Bede and Jarrow*, commissioned wood engravings enlarged for Newcastle Metro

Station on the Tyne & Wear Metro, entitled *From the Rivers to the Sea.* The prints were printed traditionally and then digitally enlarged to life-size for this commission.

ABOVE John Phillips, *Which Way to Go?* digital inkjet from sand relief. The image may be printed by inkjet or by relief impressions in sand. Its reproduction embraces the dichotomy implied by the image and its title. 36 × 53 cm (14¼ × 21 in.)

Transfers

This technique uses a found or printed image which is then transferred to paper to form a print. Counter-proofing is one such method, whereby an etched, inked plate is printed onto tissue paper, then the tissue paper is printed onto a fresh piece of printing paper while the ink is still wet. A photocopy can then be transferred onto a plate and etched, or it can be transferred onto a litho plate and processed.

In the case of etching, the photocopy is laid face down onto a degreased metal plate. An environmentally friendly acetone, such as non-acetone nail-varnish remover pads, as recommended in *Monoprinting* by Jackie Newell and

BELOW Aine Scannell, *Paper Dolls*, installation detail, lithography and relief, digital photocopy, oil sticks, and drawing pins. 80 × 140 cm (31½ × 55 in.)

Sheila Sloss, *Receptacle for the Imagination – Window 1*, installation, collagraph, screenprint, photo etching from used plate and collage, 100 × 100 cm (39½ × 39½ in.)

Cristene Hoei, *Weaving series no 6*, relief monoprint, from fragments of woven frabric pasted onto hardboard, 50 × 140cm (19½ × 55 in.)

Dee Whittington (London: A&C Black, 2006 and 2008), is rubbed vigorously over the back of the photocopy. Newsprint is placed over the top and everything is run through the etching press with good pressure, forcing the carbon to transfer onto the plate. Intaglio printmaker suppliers stock Quick Off as a transfer solution. If, however, acetone is used, wear rubber gloves and work with good ventilation.

Once the image has been transferred, the carbon will act as a ground and the plate can be etched. The carbon will be etched away quickly, so it is recommended that you take a test strip prior to etching the plate.

With plate lithography, the same principal applies as with etching. Once the image has been transferred, the litho plate can be processed and printed. Note that transfers can be a temperamental process, yielding either very good results or none. But persevere – they are well worth trying.

Alternatively, transferring directly to paper by substituting the metal plate with a damp, heavyweight printmaking paper, which then becomes a monoprint, will also work with this method.

Wrapping-paper transfers

Use the very cheapest wrapping paper, such as the patterned paper sometimes used to wrap flowers. This transfer can be soft and delicate, used as a background to drop a print onto or as collaged elements. It works particularly well on soft well-worn cotton. A hot iron is required.

Place the wrapping paper face down over the cotton and in a jar prepare a mixture of water with a splash of white spirit and a small quantity of washing-up liquid. Shake vigorously and paint the mixture over the back of the wrapping paper. Lay newsprint over the top and iron using a hot iron.

9 SETTING UP A STUDIO

Working within a budget need not be a daunting prospect: most studios have been set up with limited funds. One of the most important considerations is to find a space that is well suited to printmaking processes and has enough room for the materials and equipment required. Many essential items can be made rather than purchased, while machinery that needs to be bought can often be acquired second-hand.

A space to work in is a fundamental requirement for any visual artist, and a printing area could easily be set up as part of an existing space. This would work very well with relief and mono-printing, as there are lots of different printing options that can be achieved by printing without a press. For all printing requirements, a workbench or a folding table is essential. In fact you'll be better off making such a table or bench than buying it; using inexpensive found wood, composite chipboard or MDF, you can tailor-make it to fit the area you'll be working in. However, it does need to be sturdy. Also, fix a space-saving shelf unit under the workbench to hold tools, ink, paper and rollers. Next, place a large piece of reinforced glass or aluminium over one-third of the workbench top for mixing and rolling ink onto the block. This will give an area for preparation and cutting as well as inking and printing.

Prints need somewhere to dry, so if they have been printed on dry paper and the studio space is small, they can be dried by hanging them from the ceiling above the workbench.

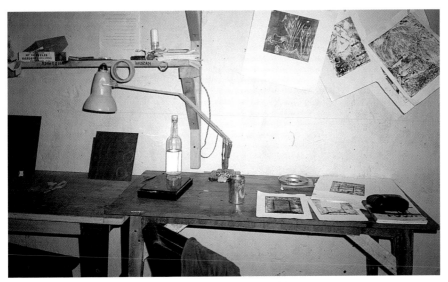

Drawing area Wildebeeste Print Studio, Lamu, Kenya 1993

Scrim drying, Wildebeeste Print Studio, Lamu, Kenya 1993

Hanging drying racks can be purchased, but these are expensive and can easily be reproduced by making a wood frame approximately 120 x 44 cm (47 x 17 in.). This should have two parallel lengths of picture wire 30 cm (12 in.) apart, running lengthways along the inside, with 40 wooden clothes pegs evenly spaced along the wires. Attach four lengths of strong twine or string to each corner and hang. To stop the clipped print from marking, slip a small piece of folded paper over the edge that is held between the pegs. Alternatively, hang a washing line and attach the prints with pegs.

There are some things on which it is much better not to economise, and the best-quality roller you can afford is an essential purchase, even if only one is within your means. The amount spent is the quality acquired, as the printing block will only print the ink as it has been applied: if the surface is uneven then the resulting print will reflect this.

There is a wide choice of cutting tools in various sizes, widths and prices. One very good quality tool will really help with cutting, and can also be used in combination with less expensive cutting tools and a sharp blade knife. For printing by hand, the printing paper needs to be thinner than that you would use for printing through a press; keep the weight of the paper to under 200 gsm. Anything over that weight is much harder to hand-print. Have a stock of white acid-free tissue paper and newsprint.

Other basic materials you'll need are:
• Palette knives (for mixing and spreading ink)
• Cotton rags and rubber gloves (for cleaning up)

- Vegetable oil (dissolves ink safely for cleaning)
- French chalk, whiting or talcum powder (to remove excess grease from the oil when cleaning)
- White spirit (a small quantity)
- A small metal bin with a lid (to store used rags and solvents. Keep in a cool dry area and for safety do not allow any solvent rags to build up for long, as these can be the cause of spontaneous combustion)
- Easy access to running water (a sink and tap)
- Hand burnishers for printing.

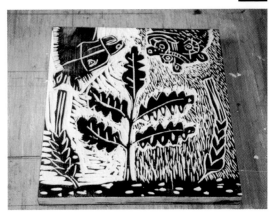

Wood block from 'Out of the wood' workshop, Zimbabwe

Of course, you'll also need printing ink. There are very good-quality water-based inks now widely available. However, if finances are limited, oil-based inks are a lot more versatile and there is less wastage, as ink left over from printing can be wrapped in plastic and stored.

Among oil-based printing inks there are specialist inks for each printing process: lithography, etching and relief. Any of these inks produce good-quality relief and monoprints.

Relief-printing using a press

A relief-printing press prints woodcuts, linocuts, wood engravings and monoprints. A printing press is the most expensive item you'll have to buy when putting together a studio. If the studio space is small, a bench press is less expensive and could sit on the workbench. Many printmaking supply shops stock small bench presses, the price being determined by the size.

A press can also often be purchased second-hand through printmaking periodicals websites, auctions, and word of mouth. There are notice boards on the premises of most print suppliers with wanted and for sale adverts.

A bookbinding or nipping press will print any relief print extremely well. Place the inked block onto another piece of wood which is just a centimetre less in size than the press, and lay the printing paper over the top and a wad of newsprint or padding over this. Then slide into position, turning the pressure all the way down as far as it will go, plus one extra turn. Release and slide everything out.

Etching, litho and relief

If you want to accommodate all these processes – etching, litho and relief – you'll need a large space. Once the budget has been decided and a space found,

a straightforward studio workshop can be put together, with some additions as before. The largest outlay is for machinery; you may find it easier to pool resources with a small group or another person, as this will reduce costs considerably.

Workbenches and storage shelving need to be put in place as before, with drying rack as above for air-drying prints. If etchings and drypoints are to be produced, some extra materials and machinery need to be acquired.

If you need to limit your spending, an etching press is the most versatile of the printing presses, being able to print all three of these processes. Alongside the etching press, you'll need to buy three press blankets. These are expensive and usually sold by the square inch. Traditionally, they are handmade from wool, and felted. Two are close-weave felts, while the third is much fluffier and known as swanskin. However, there are alternatives. An old woollen blanket cut to size three times or a piece of sponge 8 cm (3⅛ in.) thick will suffice. Neither of these will last as long, but both are perfectly serviceable. Manmade substitute fabric will not work, as when printing an etching or drypoint in intaglio from damp paper, it will not absorb the moisture from the paper.

By reducing the printing pressure, linocuts can be printed very successfully through an etching press. Woodcut printing blocks made of birch plywood or MDF will be easier to cut, and will also print well. Before printing, on the bed of your press you should set two wooden strips, or runners, the same length as the press bed and the same height as your printing block, approximately 5 cm (2 in.) thick. Print using the same pressure as you would for printing linocuts, using two press blankets or felts underneath the printing block.

Plate lithography also prints very successfully using an etching press and blankets. However, you'll not be able to print wood engravings this way; they'll have to be printed by hand.

A full-size free-standing press can be extremely heavy, so before you buy one check that the floor is secure enough to hold the weight of the press. The weight can be dispersed more evenly if the press stands on two large pieces of 19 mm (¾ in.) plywood or timber. Moreover, if the studio floor is concrete and on the ground floor of a building, there is no problem. A half-size (demi) free-standing press is the equivalent of two heavy men standing together.

For etching you will need:
Chemicals
Ferric chloride to etch the metal plate does not give off fumes and can be stored either in a separate cupboard or in a metal cabinet. Acetic acid can also be stored in this way.

A selection of labelled photographic trays, at least three.
1. Ferric chloride
2. Acetic acid
3. To dampen paper, but if this is too expensive, a large sheet of plastic to wrap and store the damp paper and a good-quality sponge will work just as well.

Shelving, Wildebeeste Print Studio, Lamu, Kenya 1993

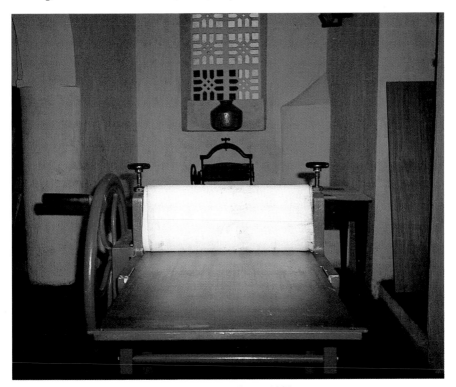

Etching press, Wildebeeste Print Studio, Lamu, Kenya 1993

Hotplate

A hotplate was traditionally used for applying grounds or ink to the plate. It can be an expensive item to buy, and as its main use nowadays is in melting grounds, you can quite easily make a more-than-adequate substitute yourself.

First, you will need a single electric ring. Then take a metal picture frame which has had the glass and backing removed and which is larger than the electric ring by a circumference of at least 15 cm (6 in.). Cover the frame with a strong wire mesh, a metal oven shelf or a metal cake stand. This should then be placed at approximately 12 cm (4¾ in.) above the electric ring, preferably resting on a metal stand. This apparatus can also be used for melting aquatint resin.

Tools

A hard 3H pencil is very good for drawing through a hard ground, as are etching needles, a compass point and traditional drypoint tools. (You can easily make a very decent etching needle by sticking the blunt end of a darning needle into a wine cork, using the cork as your handle and etching with the sharp end.) A scraper/burnisher is good for removing unwanted etched areas. To avoid scratching the plate, rub a little machine oil onto it before burnishing and scraping away the unwanted metal.

Aquatint

Aquatint resin is available as a lump or in powdered form through specialist printmaking suppliers. There are lots of different ways to produce tones through etching, and purchasing an aquatint box is very expensive. Aquatint also needs great care when being handled, and ideally should be kept in a separate room with a high-quality air-extraction unit. You should always wear a dust mask when using this material. If you are setting up a studio at home, it would be easier and safer to use alternative methods to obtain these kinds of tones.

If you are setting up a workshop for the first time, the cost of buying an aquatint box may be prohibitive, and in any case two alternative methods exist, both of which are inexpensive. Ideally, both methods would be best executed outside, or at the very least in a well-ventilated room. It goes without saying that you should always wear a dust mask.

Firstly, a large glass jar or tin can filled up to a third full with resin powder, and covered with two layers of scrim, tarlatan or muslin held together with elastic, can be shaken directly onto a metal plate and then melted gently onto the hot plate. Care needs to be taken, as if the resin powder burns it will not work. A candle or wax tapers held under the plate will also work well. The second method comes with thanks to Jane Stobart and involves a cardboard box with a rectangular piece cut out of it, which is then sealed with parcel tape. The box holds powdered resin, which needs to be disturbed by vigorously shaking the box. The parcel tape should then be removed and the metal plate carefully placed

into the box through the rectangular opening. Reseal the tape and leave for 20 minutes while the dust settles on the plate. Melt the aquatint onto the plate by heating it as before.

Metal files
Two metal files, medium and fine, are required for filing plate edges. These are available in any hardware shop.

Printing ink
Etching ink, an oil-based ink which can either be bought or made, is the traditional ink used to produce a print. However, you may want to use other inks. Litho and relief inks are a lot more viscous than etching ink and will take longer to remove from the surface of a plate.

Scrim, tarlatan and muslin are sold by the metre or by the roll from printmaking suppliers and can be hung on the washing line to keep for future use. Heavy card, biscuit board or mounting card can be cut into pieces to apply the ink. Any offcut can be used for this economical purpose; not a lot of ink is wasted using this method.

Drying prints
Intaglio prints need to dry. The easiest way to do this is to cover each print with white tissue paper and individually sandwich each one between pieces of blotting paper. Every three prints or so, interleave a piece of plywood large enough to cover the print and blotting paper. Once the stack of prints is completed, place a weight on top. The prints can take as long as two or three weeks to dry. Printmaking blotting paper and

A hot plate, Wildebeeste Print Studio, Lamu, Kenya 1993

A Nipping Press, Wildebeeste Print Studio, Lamu, Kenya 1993

acid-free tissue is available through both printmaking supply shops and paper merchants. It can be bought by the sheet but is much cheaper to purchase by mill pack.

An alternative is to stretch the print onto a drying board with water-based tape such as gum strip, or lay a sheet of newsprint over the damp paper and cover with the cheapest cotton sheeting. The paper will dry overnight, but the oil-based ink will not be dry. The print can be cut away from the board, but any deckle edge will be lost.

Lithography

A litho press will print litho and monoprints. An etching press will successfully print plate lithography. Erasol and Prepasol should both be kept in a metal cabinet. Use gum arabic, preferably in liquid form, and green etch. These are available from printmaking suppliers and are usually sold in 5-litre containers.

You'll also need French chalk or talcum powder, and you should also acquire a variety of drawing implements, as well as specialist litho chalk and liquid tusche. Two buckets for water are also crucial, and so is a sponge. This needs to be of the very best quality. You can buy a printmaking sponges or a natural sponge. A cheap, manmade sponge does not work at all well. Finally, access to water via a large sink is an essential commodity when using litho.

Silkscreen

A studio set-up for silkscreen can be put together using costly specialist equipment, including a silkscreen vacuum bed, a drying rack, processing equipment, a light box, squeegees and inks. However, it can also be very simple, straightforward and affordable.

Access to water is important.

A workshop studio bench, hanging rack and shelving can be put together as before, and the screen and bed previously described can be placed on the workbench. When not in use they can be stored.

Squeegees can be purchased through print suppliers; it is well worth buying one of good quality. There is a choice of hard and soft rubber; if possible, purchase one of each. Jane Stobart, in her book *Printmaking for Beginners* (London: A&C Black, 2005 and 2007), describes using a car window cleaner with a rubber blade and a plastic handle; this could also be tried.

Unused ink can be stored for reuse in a plastic cup with a lid. You can make a simple wooden box frame to act as a light box, with a bulb attached underneath; or the box could sit above a small lamp. Glass covered with tracing paper can be laid over the top. An alternative to a light box that also won't cost you a penny would be to work against a windowpane. It works surprisingly well.

A studio needs to pay its way to cover basic running costs. If the workshop has been put together in collaboration with others, the costs can be shared. Materials such as paper, plates and blocks would be purchased individually, but there are other sundry materials for which shared payments should be arranged.

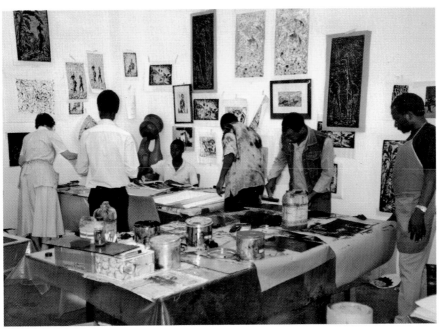

Print workshop from 'Out of the wood' workshop, Zambia

If the space is large enough, a work area could be put together for each person, or storage space at least could be made available. Artichoke print workshop in London, set up by Melvyn Petterson and Colin Gale, is a very successful printmaking facility, where printmakers pay a fee to cover the running costs and studio rental. They have a key-holder service so that the studio is available 24 hours a day and artists who join this scheme can work at any time. Prints are sold through the studio, and, should anyone require technical help, contact teaching time can be booked in advance. Plan the running costs beforehand to work out what may or may not be possible. If the studio is a collaborative project, meet regularly to discuss plans and ideas to promote the workshop. There are several possibilities. For example, open studios could be held, where members of the public could come and view, and possibly purchase, the studio members' work. Weekend workshops could be offered by advertising on print suppliers' notice boards and in periodicals. A studio website could be produced to promote the studio and the artists sharing it. School workshops could be offered either in the studio or in a school. Look into finding funding for a personal project.

10 EXTENDED PRINTMAKING

Extended print is an approach to printmaking that expands a practice beyond the limits of the press size, the types of materials used to construct a print work and the final scale of that work. It may result in a one-off work or in multiple works, in printed canvases or print on found objects, clothes, textiles, even walls, or in other unconventional uses of printmaking. The scale of these works can range from the small and portable to large elements of an installation or site-specific piece. It is a use of printmaking not in opposition to traditional practice, but rather an extension into the possibilities now being explored in other areas of contemporary visual art. The aim is to produce art works that are the equivalent in their range and depth of concerns to those found in modern painting, sculpture and installation works, but achieved through the particular qualities of printmaking.

Repetition is a simple device for expanding both the size and effect of print works. Large surface areas can be printed to create surface-covering materials, decorative wallpaper-like works or large-scale hangings. Multiples are also a simple way to produce a great number of single images, which can then be given away or posted to a wider audience than would see the work in a gallery.

Extended practice often uses appropriated imagery either by making printed reproductions of an image within a work or by simply printing over an existing image to create a layered print with a reproduction as its background or base. Appropriated images can be printed and collaged into new juxtapositions and meanings. In fact, printmaking offers limitless potential for a wide range of imagery to meet in new inventive and transforming combinations.

Nigel Ashby, *Little Cat Chair*, Pencil on magazine image, unique print, 7 x 7 cm (3 x 3 in.)

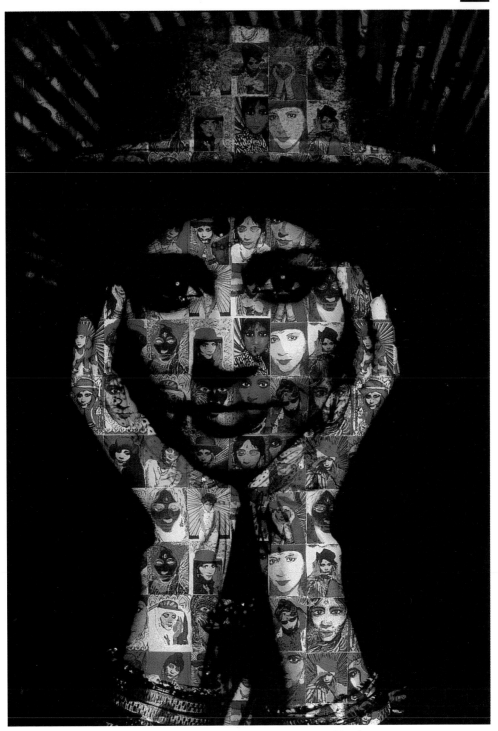

Chila Burman, *Auto Portrait B*, digital inkjet print, 57 × 76 cm (22½ × 30 in.)

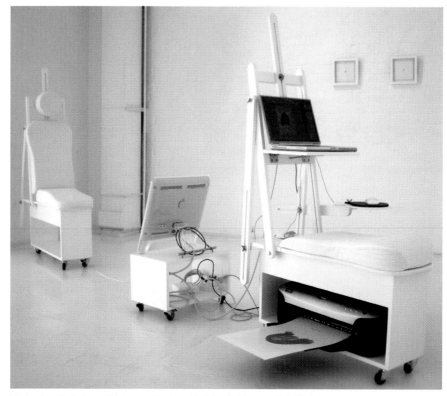

Katherine Bull, *Data-Dialogue* (series title), *Dialg Viewer*, digital pigment print on coated paper, 32 × 37 cm (12½ × 14½ in.), each series in edition 3

This is particularly the case with digital work, where the possibilities of layering, altering, manipulating and combining different sources of imagery can be achieved using a computer.

Photocopies offer a simple and direct way of introducing appropriate and multiple imagery in combination with more traditional methods or as a collage element in the finished work. These are easily reconfigured, cut and shaped to fit into the print work produced. Photocopies also offer a cheap means of reproduction for multiple works such as pages for books.

Relief printing and monotype methods are easily adapted to print on a variety of surfaces, whether textiles or uneven surfaces comprised of different materials. Using plastic sheets from which to print allows for the sheet to be bent or curved to a surface to transfer an impression onto an object. Rubber sheet is a particularly flexible material for printing onto uneven surfaces or those with a complex shape. Paper stencils are also flexible enough to follow uneven surfaces. The imagery can be obtained from computer printouts and photocopies. Once cut and placed, the assembled piece can be easily printed by rolling ink over it within the limits of the stencil paper. For printing on more complex shapes or objects, consider deconstructing the object or textile, then

printing over the disassembled pieces, then remaking the object to create the work. Another method is to use a thin textile or tissue paper that is already printed with the imagery you want, which is cut and glued to the form as a kind of a printed skin over the object.

Installation print work requires many different printmaking approaches, both new and traditional, to complete a fully finished work. These can vary from producing supporting backgrounds, textile coverings or constructed forms, to facsimile elements and printed found objects. These multiple print elements will cover all possible uses of printmaking, reproduction, unconventional materials and processes. Installation work requires great invention and a very adaptable attitude.

Extended printmaking is therefore a term to describe the unconventional use of printmaking for its own particular qualities to form complex works concerned with contemporary issues within visual art, resulting in broader forms of print work such as bookwork, installation, printed objects or sculptures, printed canvases, site-specific works, multiple works, postal art and one-off pieces.

Scale

An important element in modern fine-art practice is to be able to produce works at both large and small scales. Traditional printmaking is conducted within the limits of standard paper sizes and presses or printing tables used. Producing prints that are life-size or larger challenges the expectations of a

Liz Collini, *Sequelae*, glazed decorated stoneware, 43 cm (17 in.) diameter monotype

Magnus Irvin, *Kimono*, woodcut, life size

gallery visitor. Increased scale confronts the viewer with surfaces and combinations of imagery for which printmaking is such an appropriate medium. The particular formal qualities of printmaking are much inflated at large scale, allowing the print surface to be read in a similar way to painting and sculpture.

Large work can be composed in several sections to complete an image, or it can be created by repeating a single image across a surface. Giant prints envelope the viewer, make a forceful statement that requires open space and distance from which to view the image. The experience is similar to viewing a large billboard ad or a still from a cinema ad. The disproportionate scale can have an epic, classical quality that holds the eye of the viewer, dominating a space so powerfully that every detail can be clearly seen from distance.

Smaller print works relate to our everyday dialogue with books, images and all forms of mass communication. The closeness of a spectator to the art work engenders a more personal relationship with the viewer, where, cradled in the hands, the feel, weight and other qualities of the printed object are easily experienced. Viewing small-scale work is a different to experiencing wall-size works hung in a gallery space, which by its greater size and layout dictates how the work is experienced. Small works are viewed close up, read in the hands, touched. These factors give strength to the notion that small-scale works are concerned with narrative, are playful, direct and less precious than larger pieces. These kinds of expectations sit well with multiple or postal works like picture postcards, short-story pamphlets, badges and stickers.

Materials

You can find many unconventional printing materials simply by scouring second-hand shops and hardware stores. Flat-pack furniture is widely and cheaply available. Canvas or textile, unprinted or in single hues, is also easy to come by. The following are all good potential sources for printing on: second-hand furniture; second-hand books; art reproductions; clothes, textiles and

Paul Dewis, *Grass Shadow*, screenprint and woodcut, 54 × 80 cm (21¼ × 31½ in.)

EXTENDED PRINTMAKING

constructed textile; wood boards or found offcuts; educational and medical charts, and maps; redundant domestic equipment; glass and plastic sheets; flat-pack furniture; found objects with flattened sides.

Printing on these materials will present problems and require planning before the print is applied. But using simple relief, stencil, monoprint, and offset and construction skills, a way can almost always be found to place a print impression on a surface. The process may take more time where the surface or shape worked on is very complex, and the object has to be disassembled into its constituent parts for ease of printing. Any object with flat sides, or material that can be laid out flat, is easily printed on. But with more complex surfaces and objects, consider what is wanted, whether it's a covering of printed imagery, or a selection of printed images in a particular shape achieved using stencils, or a collage of printed forms. Much can be achieved by collaging forms onto canvas, textile or thin printed paper, which can then be cut out and glued to the surface of the object.

Clothes patterns, as well as templates created for furniture and other objects, are useful if you're constructing a piece in an alternative material (maps cut to a clothes pattern, furniture templates constructed from stiff cardboard). Work can be made from cut patterns, or from preprinted sheets of the material or materials chosen, then assembled in its final form. Work constructed this way has an authority as a finished form that overworked found objects do not.

Test samples of the surface you are going to print on to see the qualities and the type of print impression that can be achieved. At the same time, be ready to find unexpected results which may add to the potential of the finished work. Flat-pack furniture offers a virgin surface that will take many kinds of print impression, whose various methods are much easier to apply before the piece of furniture has been assembled.

For objects that cannot be taken apart, or for textile, clothing or found objects that must remain in one piece, overprinting can be achieved by relief, stencil and transfer processes. Try to avoid seams, fixings, buttons or other forms of overlapping surfaces, as these will not take a printed impression from hand-burnished relief blocks. There will be areas clear of uneven interruptions of the surface which can be printed by offsetting, hand-burnished blocks or stencils. Most objects or pieces of clothing can be printed in sections so that the majority of the surface can be covered. Some objects have a surface that is so complex that the only way to cover the surface is to fix pieces of preprinted and shaped paper, cloth or tissue paper to each of the object's numerous facets. Stencils shaped to the forms of such facets are also a simple way of placing a print impression on an object.

Methods

Stencils
Stencil sheets provide a very flexible way of transferring an image to print on unconventional surfaces such as clothes, canvas, furniture and found objects.

Jonathon Narachinron, *Nara Fruit Installation*, screen print, 182 × 182 cm (72½ × 72½ in.), paper engineered

The image can be traced; the highlights and contrasting dark areas can be picked out; colours and shapes can be separated on the stencil sheet. Then the printing areas can be cut out ready for printing. This process can be simplified by scanning an image into a computer via Photoshop software, then separating or processing the scanned image into a bitmap, a line image or four sheets of a colour separation, which can then be printed out at the size required. The processed image is then cut out to form a stencil ready for printing. For those without access to a computer, or the skills to use one, photocopies can be used in a similar way.

Printing the stencils
The stencils need to be secured on the surface to be printed – either with masking tape or if necessary spray mounts – then gently laid in position ready for printing. Print by inking up a roller and passing it across the exposed printing area of the stencil. This will leave an impression on the surface under the stencil, though you may need to ink it a second time to get a good impression. Allow the ink to become touch-dry, then carefully remove the

Aine Scannell, *Dukka*, plate 45 cm (17¾ in.) diameter, monotype transfer onto ceramic, using lazertran on readymade dinner plate

stencil to reveal the stencil impression. For colour-separated images the next stencil can be lined up with the printed image and printed with the next colour stencil and so on until the image is completed.

Monotype

Monotype is a very useful one-off and freely expressed form of print. It can be applied to different surfaces in several ways, the most adaptable being to use a plastic sheet that can be hand-burnished from the back to print an impression on an irregular surface. Thin rubber sheet is more flexible but is harder to control, position and draw on. In both cases the area being printed needs to be inked up then worked on with rags, sticks and brushes to produce the image. Remember that the printed image will be a mirror of the drawn image.

Once the drawn monotype is complete, place in position and hand-burnish the back of the sheet with a clean rag to create the printed image. With practice and care, you'll find it is possible to make a monotype on the same sheet in a number of colours (if the colours do not intersect or overlay each other on the sheet), and thus with three or more printings to build up a complex colour image. Transparent plastic sheet is the best to use, as being able to see the previous print through the sheet makes registration a lot easier.

Metal and glass sheets make good surfaces to monotype from, but since neither material is very flexible, the object or surface needs to be laid on the monotype plate surface, then pressed or burnished from the back of the material being printed. Glass and metal sheet work best with materials that are flat or that can be flattened, such as disassembled objects or flat cloth, before the object is reconstructed.

Sticky labels

Blank sheets of sticky labels are available to buy in various sizes and shapes. These can be printed on through a computer printer or photocopied on in both black-and-white and colour. Printed labels are a very direct way of applying an image to any form of object and any chosen surface. Mixing different sizes and shapes of stickers, composition becomes very open and free.

The label's paper side can also hold very detailed, complex images, both graphic and photographic. Though the cost is large, it is now possible to feed large sticky-label sheets through a large-format printer to produce life-size images; these are particularly popular with street artists because they can easily be fixed to walls in any town or city.

Lino blocks

Like the plastic sheet used in monotype, cut-lino blocks are flexible enough to print on rounded or faceted objects. Lino blocks can be hand-burnished on the back to print onto many surfaces. An accumulation of cut lino left over from various editions can be reused to make new images, either by cutting certain elements of the blocks for particular images of interest selected for printing, or by simply inking up areas so as to print only selected textures and

Adrian Taylor, *Race*, monotype drawing scanned into photo shop, digital image, 35 × 25 cm (13¾ × 10 in.)

images. These are then hand-burnished on the back to print onto the chosen surface. Their advantage is that the selected image or portion of an image can be repeated and reinterpreted.

Stamps

Stamps can be made up very cheaply (from an original line-drawn design), or they are available at stationers and toyshops with different images or instructions on the printing face. But it is also cheap to have individual sets of designs made up. Stamps are easily printed on most surfaces and require little inking to give a good impression.

Sponges, rubbers and plasticine (substitute modelling clay)

Sponges can be cut into simple forms for printing. If you need a simple repeated motif, a sponge can provide a quick way of covering large areas, following the form of a found object or cloth to be printed upon. Small rubbers can be carved with an image in the same way as lino blocks. Rubbers are easily

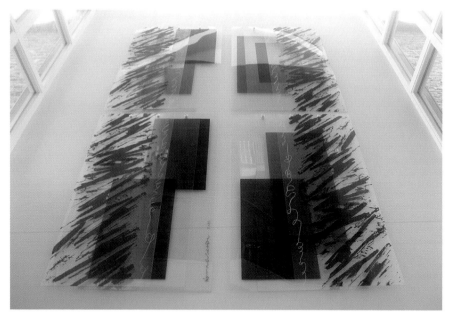

Norma Silverton, *Klesmer*, screen print on perspex panels, each panel 100 × 60 cm (39½ × 23½ in.) in sets of 4

handled and pressed against a surface; they are often shaped like animals, cars or other objects, which can easily become a motif. Plasticine or other substitute modelling clays can take and hold an impression from the surface of a natural object or piece of machinery, or from any complex surface. This is easily inked with a roller placed on the surface to be printed, and printed with gentle hand-burnishing.

Tissue transfer

If the object has a lot of undercuts, a surface that will not hold a printed impression, or is a complex, faceted object, tissue transfer may be the best way of applying an image. The aim of this indirect method is to place a skin of printed imagery over the complex form and use PVA glue both to attach the printed tissue and to make the render skin translucent. The tissue can be monoprinted or printed from relief blocks, both lino and wood. With older photocopy machines, the tissue paper can be fed through if attached with tape to a sheet of photocopy paper. Cut the photocopied tissue to cover the surface of the object, cloth or form being worked on, then attach it using watered-down PVA glue, first on the back of the printed tissue then across the surface to which it is intended to cover. The tissue will dry and harden into a translucent skin that follows every undercut and facet of the covered, printed form. With practice this method will teach you greater control of where printed imagery can be placed.

Bear in mind that with trial and error all these methods will work on most surfaces, though it may take a mixture of different methods to achieve a print

Aaron Wilson, *Into the Plains*, screen print installation, dimensions large and variable, screen print on panel includes over 260 separate prints printed onto a sign board. The signboard is cut and arranged as an installation.

Tim Dooly, *Mixed product*, screen print installation on panel, inkjet, mixed media, dimensions variable

on a surface. Some plastics may only accept a printed skin of tissue and not a direct impression.

Glass

A glass surface will certainly accept an impression, though one that is unlikely to be very durable. If the image is only for display or for a temporary period, laying another sheet of glass on top of the printed sheet, effectively sandwiching the printed image in the middle, should give adequate protection for most display purposes. All the print methods described in this chapter can be used, but for more resistant printing on glass please refer to *Glass and Print* by Kevin Petrie (London: A&C Black, 2006).

Collage

There are two approaches to collage cover: firstly, collage in the form of using layered paper, cut-out newspaper imagery, or other flat, found materials glued or combined to produce an image on a supporting surface; secondly, the seamless collage created by laying and reworking an image on a computer, and printed on a large-format printer.

Collage and photocopies

Photocopies offer a means of obtaining copies of imagery without affecting the original, and a cheap way of producing multiples of an original to be used in a collage. It is also a method whereby a lot of different imagery in either black-and-white or colour can be collected for collaging onto a chosen object. Mixtures of black-and-white and colour create a strong visual impression for further print work onto a given surface. Photocopies are also a simple way of conveying a photographic image to the surface you intend to collage.

Offset as collage

Offset uses the length of contact of a roller with the printed surface, as determined by one turn of the circumference of the roller. A roller will pick up detail within the length of its roll over an inked surface such as old relief blocks or a textured surface. Once the inked impression has been transferred to the roller, it can be printed easily by rolling it onto another surface. The roller can then be cleaned and the action repeated if necessary.

Digital collage

Imagery from various sources can be scanned into a computer, and then via software such as Photoshop it can be layered, cut out, pasted, overworked and combined into a seamless collage to be printed at a larger scale through a large-format printer. The quality of the collage and its complexity will depend on the experience of the computer operator, but even a novice can produce very professional results. The final digital product can be printed on a range of surfaces including plastic sheet, various weights of coated paper, coated canvas

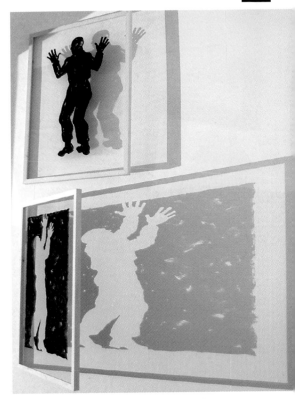

Jane Stobart, *Installation; Windows* 7–9, monoprints on glass, projected light and animation, 240 cm (94½ in.) high

and cloth. The image is repeatable for any required length depending on the length of the material you are printing on. Of course, there is also the cost to consider, digital print being a far from inexpensive medium.

Most digital prints function as wall pieces, but there is no reason why soft sculpture or even a piece of clothing could not be constructed using this method. Although producing a digital print is costly, it could also provide a material for construction or collaging into more complex pieces that are difficult, or no less expensive, to produce by other means. Digital collage is very new and developing rapidly, and while at the moment it could be seen as a somewhat specialised, expensive technique, it may also soon fall within the technical competence as well as the limited budgets of the majority of printmakers.

11 LOOKING, RESEARCHING AND RECORDING

■ Searching for subject matter, finding an area of interest for an art work, is a difficult and complex activity. This chapter gives general points to consider when researching ideas and imagery – such as finding the right form of notebook for a particular purpose; considering how to structure the record you have made; what to look for; where to search for sources; and the various means of recording what you find. At the end of the chapter there is a study example to demonstrate how research for a selected topic could be approached.

Notebooks

A notebook serves to externalise a person's thoughts and help them find the right path forward among a number of similar possible paths. It also helps to focus the artist's thoughts about the form that interests them, while at the same time allowing associated ideas to be recorded for future reference.

The form of a notebook may anything from a simple collection of sketches on a subject to a referenced collection of drawings and writings on that subject. The scope and size and level of organisation of the notebook will depend on the requirements of the art work you intend to make, and the limits of your own knowledge when searching for inspiration for that work.

Traditional artists record sketches outside the studio, making studies, drawings and notes on a subject to take back to the studio to work from directly or to turn into scaled-up working drawings for an art work or print. This tried-and-tested method still works well, particularly for those artists who are clear in their minds as to their chosen subject matter. When a given subject matter presents itself in easily found forms, such as it does in still life, portraits or landscape, the process of research at first appears easy. Hence the landscape artist will make records of aspects of the landscape – plants, buildings, seasons, sets of colours or weather conditions – that are important to the scene. But even this basic form of research may need to be extended by recording local myths, past events or stories associated with a region, or the physical aspects of a geographical feature. For many contemporary artists, searching for imagery or information is a complex exploration of resources and collections of knowledge beyond those used in the traditional background research for an art work or print; hence the need for a well-organised notebook.

On top of the visual and cultural investigation that will influence the content of a particular art work, its proposed form may also dictate new materials, mediums and processes, all of which will need to be researched. So,

Street sticker, London 2004

for any artist who is fully engaged with every aspect of their subject, the purpose of a notebook is much more than simply to record a collection of impressions about a subject. However, this should not be seen as a task, but as an opportunity to lay the foundations that support future exploration – resulting, it is to be hoped, in completed art works and prints that are well referenced both in formal construction and cultural meaning.

Structure

All notebooks need a structure, however basic. Research into sources can become useless if a reference cannot be easily found. The easiest form of order is chronological: as the imagery, drawings and information are found and made, so they are recorded. Other artists may have a more formal approach, dividing the notebook into particular areas of interest via sketches and collected imagery, and recording written information next to working drawings for future reference. There are also those who will organise by topic or project, keeping a strict structure, or even separate books, for distinguishing between different types of information needed for a print and its production. A further, very effective way to structure a notebook is to use the form of a diary of thoughts, with collected information recorded in real time, where the progress of an idea can be clearly seen, edited or changed by discoveries made on its way to becoming a completed artwork.

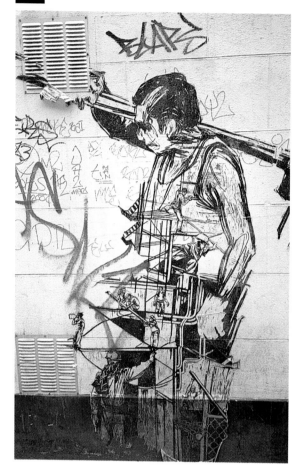

Street sticker, London 2005

Looking

Seeing is taken for granted. It appears to be a matter of common sense, requiring little mental effort. However, truly observing what is in front of our eyes is a skill, using the human eye to isolate important details or information. The practice of objective drawing, of recording the details and forms of objects or figures, has great value in terms of being an exercise in skilled looking. An artist-printmaker will be constantly aware of anything associated with their own interest, to the extent that such details will appear to jump out of a viewed display or collection of which they are a part. Awareness comes through training the mind and the eye to be curious wherever and whatever the circumstances. Such a training is slowly acquired though time visiting museums, collections and galleries, or from reading books or studying various kinds of printed materials, but in any case the act of looking for sources generally follows these stages towards the production of an art work:

1. Assemble a broad collection of good source materials from many different origins, looking for connections and identifying what is important as a visual source for future work.
2. Collect information about your subject from more formal collections and published sources, making drawings and recording impressions. Begin to structure your findings.
3. Seek out specialist knowledge on how to construct a work as well as associated histories and concepts, with further exploration carried out in working drawings.
4. Use your collected sources to form plans and refine ideas for a completed work.

Jessica Meyer, *Skin City*, non toxic skin transfer as seen in relation to the body

Where to search

Influences can be found anywhere, whether you are living in a city or in the countryside. Often a small detail in the environment may catch the eye, or a particular atmosphere, or other elements such as certain colours. For the printmaker, local sources of print imagery are everywhere. The local environment will have examples of faded posters, waste packets, magazines, thrown-away newspapers, and shops full of printed packets. Printed images are a natural part of our everyday experience, one aspect of the complex visual collage so typical of modern urban life. The difficulty, therefore, will not be in finding sources of ideas and imagery, but in selecting those that suit your purposes.

Photography

A camera that is easily carried and can have the flash switched off is an important means of keeping visual records of a chosen subject. Try to use a camera with a notebook to record details such as where and when the subject was shot, and any other facts that need to be remembered. A camera that can focus close to, and allows for different modes of flash, will be very useful.

Work in series and in detail; do not just take one photograph of a source, but many shots from different viewpoints. Remember that the mind's eye records impressions not details. A carefully built series will be better to refer to later, even if only one in ten images is used to make a work. Always keep a

camera ready for chance occurrences or occasions when clear detail needs to be recorded.

Areas of interest for printmakers

A knowledge of the historical and other forms of print is important to a printmaker; an old-fashioned process can often be adapted to suit your current needs. Historically as much as today, printed products have assumed many different forms: badges, postcards, maps, stamps, product containers, old books, comics, newspapers, tickets and posters, to name a few. Many of these printed products have become collectable, and there are specialist collections and publications which can be consulted. But being collectable these older objects will have a high market price and thus may be out of range of a personal collection. However, the print industry is now producing new versions of print collectables. These products are often connected with publicity for television programmes or mass-market promotions, but they could easily be the start of a contemporary collection.

So much material has a temporary life, but fashions still tend to rely on cutting-edge print technology to communicate their charms. This is print made for the moment, easily forgotten and thrown away. Collecting this material while it is new should be possible for most people, and such a collection will help you keep abreast of new visual ideas.

For further information, see the following sources:
www.vintagepostcards.com/postartistbiographies.html
www.nypl.org/research/chss/spe/art/print/print.html
www.tate.org.uk
http://www.thebritishmuseum.ac.uk/pd/pdhome.html
http://www.cartooncentre.com/

The Web

Computers linked to the World Wide Web are a strong research tool. With a few details it is easy to find connecting information and specialist detail. But the nature of the Web means that information is highly edited and not always well-referenced or checked for accuracy. A web search is a good source of general imagery and unforeseen connection, but only as part of a thorough research process of other, potentially more reliable sources.

Street stencils: a study example

Street stencils are featured here as an example of how to research a particular subject, but the process is the same for any subject. The images associated with this chapter are a small selection of a large collection of street stencils made in recent years around the streets of East London.

Street sticker, London 2003

Street sticker, London 2005

Street stencil, London 2005

Street stencil, London 2005

Subject

Street stencils are an aspect of urban graffiti seen across the world. Most graffiti is hand-drawn onto the walls and empty spaces of the urban environment, but street stencils are among a range of printed graffiti that are common features of the contemporary urban landscape.

Street stencils are designed by scanning imagery or traced forms into graphic-image software on a computer, processed into contrasting forms and then printed out ready to be cut into stencils. The imagery often comes from reworking images from popular culture or forms created by an individual's iconography. The cut-out stencil is then applied to a wall and sprayed to leave behind the image.

Search

Street stencils are common in an urban environment, but like all graffiti they only have a temporary life before they are removed by local authorities. Therefore, stencil works are best photographed as soon as you come across them. They tend to exist in parts of the towns or cities that are more attractive to youth, near bars or other popular venues.

Many street-stencil artists or groups have formulated theories and ideas about their art form. These vary from notions of cultural or political activism to simpler promotional ideas for their own work. Moreover, the milieu is in a constant state of flux, with new artists and artistic directions appearing every few weeks.

The following are good sources for street-stencil art:
www.stencilgraffiti.com
www.stencilarchive.org
www.banksy.co.uk
www.stencilrevolution.com
www.rashfilm.com
www.james-dodd.com

Look out for groups such as Bast, Joystick, Toasters, the London Police, and Swoon. It is also worth consulting a few recent books on the subject: *Street Logos*, by Tristan Manco (London: Thames and Hudson, 2004); *Sticker City:*

Paper Graffiti Art, by Claudia Walde (London: Thames and Hudson, 2007); and *Stencil Graffiti Capital: Melbourne*, by Jake Smallman and Carl Nyman (New Jersey: Mark Batty, 2007).

So following the suggested earlier example of four stages of investigation of source materials:

1. Identify the subject – in this case, street stencils. Start recording examples with a camera. Do a Web search. Choose a particular aspect that interests you. Record your observations in a notebook.
2. Read individual and group artist statements. Find specialist studies. Continue gathering information in a notebook, now in a more structured form, and put in order the photographic evidence you have gathered.

Street stencil, London 2005

Emma Calder, *Book of Digital Stickers*, 4 × 29 cm (1½ × 11¼ in.). Individual stickers 2 × 4 cm (¾ × 1½ in.)

Emma Calder, *Stuck Flat*

3. Conduct any further research in specialist records or collections. In the case of street stencils, records are most likely to be photographs taken by interested parties and available through websites. The subject matter is still so new that there are few formal studies, just as there are unlikely to be examples in museums or established art collections.
4. A wide-enough range of references will provide you with a sourced snapshot of current street-stencil work. With any luck, the ideas that arise from the research should form the basis of a future art work.

In the visual arts truth is a relative term, so there is no single effective system for doing research. However, it is important to gain a broad awareness of the field you are interested in, in terms of ideas or theories and the visual sources associated with those ideas. Good research reveals not only the scope of the immediate subject, but points the artist towards new, perhaps unforeseen, directions.

Hilary Paynter, *From the Rivers to the Sea* series, *Newcastle*, commissioned wood engravings enlarged for Newcastle Metro

CONCLUSION

The artists' prints reproduced in this book have come from across the world. Our objective has been to showcase as wide a range of printmaking techniques and processes as possible, where those techniques and processes have been used in an affordable way.

These examples show just how varied and creative printmaking can be. With initiative and resourcefulness, all of the print processes represented can be achieved on a budget, and demonstrate that inventive printmaking does not mean having to spend a lot of money.

Artist Anne-Marie Foster (see front-cover image) works from a small studio in her home. She produces unique prints using mixed media, monoprint, digital printing, hand-drawing, woodcut and drypoint. She often uses found elements of past prints collaged within the image. The completed works are large. To produce her final image, which has been made from a series of printed techniques, Anne-Marie is constantly developing attachments and papers, hooks and eyes and eyelets, produced on a small scale to suit her needs.

Artist Janie George's print *A History of Stars* has a graceful monoprinted background, to which she has added and overprinted photocopy transfers of planets using plate lithography.

Peter Dover produces large-scale images using woodcut, monoprints and sand. He prints without a press by standing and gently stamping across the surface of his inked woodblocks to print the image. After each successful print has been taken, he reworks his blocks so that from one image lots of different pieces can be produced. His printed blocks are ongoing, often reused as starting points for the next image, with subtle changes and developments.

Adapting everyday materials that can be found, acquired and collected can save a lot of money, which can then be spent on a purchasing a few very good-quality items that can be used for a variety of printmaking techniques. One good roller is an

Jonathon Gibbs, *Fish Box*, wood engraving, 5 × 4 cm (2 × 1½ in.)

Gill Golding, *The Physical Inconvenience Of A Rabbit In The Mind Of Someone Thinking*, etching, with Photoshop scanned image and drawing, 21 × 25 cm (8½ × 10 in.)

Janie George, *A History of Stars*, monoprinted background, litho from photocopy transfers of planets, 56 × 76 cm (22½ × 30 in.)

Pierre Julien, *Tree Heart*, etching, 50 × 50 cm (19¾ × 19¾ in.)

essential purchase, and can be used in lots of different ways. A few choice tools and materials can be also used in conjunction with cheaper equivalents. Using cheaper or homemade materials does not mean compromising the integrity of the initial idea.

Presenting work for exhibition

Traditionally, prints are exhibited in a frame – either free-floating within a box frame, or mounted within a simple, flat frame. As this can be expensive, consider the alternatives if it suits the work. A cleanly printed image on mould-made paper, which has been given space within which to sit, can be very simply pinned in place. There are a lot of choices in pinning work. Standard dressmaking pins, clear coated mapping pins and white-covered drawing pins can all work well. A bulldog clip can be hung from a small tack in a wall, and the print clipped in place.

Martin Thomas, *Fairy Cave*, digital print, 56 × 76 cm (22½ × 30 in.)

Freya Payne, *Under the Cover*, etching, chine collé and lino cut, 30 × 31.5 cm
(11¾ × 12¼ in.)

Anthony Lee, *Four Heads*, screen print and photocopy, 28 × 28 cm (11 × 11 in.)

Paper-engineered prints and packaging can be placed on a shelf, as well as strategically placed on a table, as can concertina artist books and scrolls. Finally, prints can be sandwiched between Perspex and bolted to a wall.

The only rule to remember with producing and exhibiting prints is that anything is possible if it suits the work and it works.

Janie George, *White Tara*, monoprint background built up in layers. White shape cut out and printed with corrugated card board as packing. 2002

SUPPLIERS

■ Printmaking suppliers

UK

W&S Allely Ltd
PO Box 58
Alma Street
Smethwick
West Midlands
B66 2RP
Tel: 0044 (0)121 558 3301
Copper and aluminium sheet.

Art Equipment
3 Craven Street
Northampton
NN1 3EZ
Tel: 0044 (0)1604 632 447
Etching presses.

Bay Plastics Ltd
Unit H1, High Flatworth
Tyne Tunnel Trading Estate
North Shields
Tyne & Wear
Tel: 0044 (0)191 258 0777
enquiries@bayplastics.co.uk
Polycarbonate sheets for drypoint with soldering iron.

L. Cornelissen & Son
105 Great Russell Street
London
WC1V 3RY
Tel: 0044 (0)20 7636 1045
info@cornelissen.com
cornelissen.com
Printmaking supplies.

Chris Daunt
1 Monkridge Gardens
Dunston
Gateshead
NE11 9XE
chris@dauntwoodengravingblocks.co.uk
Wood-engraving blocks.

Hunter Penrose
32 Southwark Street
London
SE1 1TU
Tel: 0044 (0)20 7407 5051
hunterpenrose.co.uk
Supplies and presses.

Intaglio Printmakers
62 Southwark Bridge Road,
London
SE1 0AS
intaglioprintmaker.com
Tel: 0044 (0)20 7928 2633
Printmaking supplies.

T.N. Lawrence and Son Ltd
208 Portland Road
Hove
BN3 5QT
lawrence.co.uk
Tel: 0044 (0)1273 260260/
(0)845 644 3232
Printmaking supplies by mail order.

John Pears
5 Witton Drive
Spennymoor
County Durham
DL16 6LU
Tel: 0044 (0)1388 818004
Press engineer and manufacturer.

Andrew Purchase
Tel: 0044 (0)1903 814331
andrewpurchase@mistral.co.uk
Plate litho chemical manufacturer.

Harry F. Rochat Ltd
15a Moxon Street
Barnet
Hertfordshire
EN5 5TS
Tel: 0044 (0)20 8449 0023
harryrochat.com
Etching presses.

Rollaco Engineering
72 Thornfield Road
Middlesborough
Cleveland
TS5 5BY
Tel: 0044 (0)1642 813785
rollaco.co.uk
Press manufacturers. Suppliers of rollers, tools and inks.

Smiths Metal Centres
42–56 Tottenham Road
London
N1 4BZ
Tel: 0044 (0)20 7241 2430
london@smithmetal.com
Metal sheets including aluminium, copper and steel.

Australia

Melbourne Etching Supplies
33a St David Street
Fitzroy
Melbourne
Vic 3065
mes.net.au
Tel: 0061 (3) 9419 5666
Etching supplies.

Mitomel International
PO Box 475
Torrensville Plaza
SA 5031
Tel: 0061 (8) 8234 9400
mitomel.com
Printmaking supplies.

Canada

Praga
50 Coronation Drive, Unit 17
Toronto
Ontario
MIE 4X6
praga.com
Tel: 001 800 844 9421/
416 281 0511
Printmaking supplies.

France

Boutique Charbonnel
13 Quai de Montebello
75005 Paris
Tel: 0033 (1) 4354 2346
Printmaking supplies.

Joop Stoop
12 Rue le Brun
75013 Paris
joopstoop.com
Tel: 0033 (1) 5543 8996
Ink and paper.

Netherlands

Polymetaal
Evertsenstraat 69C
Leiden 2315 SK
polymetaal.nl
Tel: 0031 (7) 1522 2681
Printmaking equipment.

USA

Daniel Smith Inc.
4150 1st Avenue South
Seattle
Washington 98134
Tel: 001 (206) 223 9599
danielsmith.com
Printmaking supplies.

Edward Lyons
3646 White Plains Road
Bronx
New York 10467
Tel: 001 (718) 881 7270
eclyons.com
Printmaking engraving tools.

Gale Force Graphics
PO Box 667
Chouteau
Oklahoma 74337
Tel: 001 (918) 479 2502
galeforcegraphics.com
Printmaking supplies.

The Graphic Chemical & Ink
Company
PO Box 278
Villa Park
Illinois 60181
Tel: 001 (800) 465 7382
graphicchemical.com
Printmaking supplies.

McClain's Printmaking Supplies
15685 SW 116th Avenue PMB202
King City
Oregon 97224
Tel: 001 (503) 641 3555
imcclains.com

Printmakers Machine
724 N. Yale Avenue
PO Box 7191
Villa Park
Illinois 6018
Tel: 001 (800) 992 5970/
(630) 832 4888
printmakersmachine.com
Etching presses.

Rembrandt Graphic Arts
PO Box 130
Rosemont
New Jersey 08556
Tel: 001 (800) 622 1887
rembrandtgraphicarts.com

Renaissance Graphic Arts Inc.
69 Steamwhistle Drive
Ivyland
Pennsylvania 18974
Tel: 001 (888) 833 3398
printmaking-materials.com

Takach Press
3207 Morningside NE
Albuquerque
New Mexico 87100
Tel: 001 (800) 248 3460
takachpress.com
Etching presses.

■ Paper suppliers

UK

R.K. Burt & Company Ltd
57 Union Street
London
SE1 1SG
Tel: 0044 (0)20 7407 6474
rkburt.co.uk
Paper suppliers.

John Purcell Paper
15 Rumsey Road
London
SW9 0TR
Tel: 0044 (0)20 7737 5199
johnpurcell.net
Paper supplies.

Australia

Blue Lake Papermill
5 Pollard Close
Mount Gambier
SA 5290
wilsonme@dodo.com.au
Tel: 0061 (8) 8725 2393
Handmade paper.

Jackson Drawing Supplies
103 Rokeby Road
Subiaco
WA 6008
Tel: 0061 (8) 9381 2700

USA

Kates Paperie
561 Broadway
New York
NY 10012
Tel: 001 (212) 941 9816

■ Print studios and workshop groups

UK

Artichoke Print Workshop
Bizspace S1
245a Coldharbour Lane
London
SW9 8RR
Tel: 0044 (0)20 7924 0600
artichoke@ members.v21.co.uk
www.printbin.co.uk

Belfast Print Workshop
Cotton Court,
30–42 Waring Street
Belfast
BT1 2ED
N. Ireland
Tel: 0044 (0)28 9023 0323
info@belfastprintworkshop.co.uk
www.belfastprintworkshop.org.uk

Brighton Independent Printmaking
Module B1, Enterprise Point
Melbourne St
Brighton
BN2 3LH
Tel: 0044 (0)1273 691 496

Edinburgh Printmakers Workshop and Gallery
23 Union Street
Edinburgh
EH1 3LR
Tel: 0044 (0)131 557 2479
www.edinburgh-printmakers.co.uk

Leicester Print Workshop
50 St Stephens Road
Highfields
Leicester
LE2 1GG
Tel: 0044 (0)116 255 3634

London Print Studio
425 Harrow Road
London
W10 4RE
Tel: 0044 (0)20 8969 3247
info@londonprintstudio.org.uk
londonprintstudio.org.uk

Triangle Arts Trust
www.trianglearts.org
International global network of artist
workshops, studios and residencies.
Includes printmaking.

■ Printmaking societies

UK

The Printmakers' Council
Ground Floor Unit
23 Blue Anchor Lane
London
SE16 3UL
Tel: 0044 (0)20 7237 6789
www.printmaker.co.uk/pmc
also
www.printmaker.co.uk/pmc/smallads.
php
*This site is a free service to buy and sell
second hand printmaking presses and
equipment.*

Royal Society of Painter-Printmakers
Bankside Gallery
48 Hopton Street
London
SE1 9JH
Tel: 0044 (0)20 7928 7521
www.banksidegallery.com

Society of Wood Engravers
www.woodengravers.co.uk

■ Periodicals

A-N (Artists' Newsletter)
a-n.co.uk

Art Monthly
artmonthly.co.uk

Art on Paper
artonpaper.com

Printmaking Today
printmakingtoday.co.uk

BIBLIOGRAPHY

Avella, Natalie, *Paper Engineering* (Switzerland: RotoVision, 2006)

Bodman, Sarah, *Creating Artists' Books* (London: A&C Black, 2005)

Chamberlain, Walter, *The Thames and Hudson Manual of Woodcut Printmaking and Related Techniques* (London: Thames and Hudson, 1978)

Elliott, Patrick & Lewison, Jeremy, *Contemporary Art in Print* (London: Booth Clibborn Editions, 2001)

Heller, Jules, *Papermaking* (New York: Watson-Guptill Publications, 1975)

Gross, Anthony, *Etching, Engraving & Intaglio Printing* (Oxford University Press, 1970)

Jankel, Annabel & Morton, Rocky, *Creative Computer Graphics* (Cambridge University Press, 1984)

Newell, Jackie & Whittington, Dee, *Monoprinting* (London: A&C Black, 2006)

Sacilotto, Deli & Saff, Donald, *Printmaking: History and Process* (New York: Holt, Rinehart and Winston, 1978)

Saunders, Gill & Miles, Rosie, *Prints Now: Directions and Definitions* (London: V&A Publications, 2006)

Smith, Alan, *Etching: a guide to traditional techniques* (Marlborough: Crowood Press, 2004)

Stobart, Jane, *Printmaking for Beginners* (London: A&C Black, 2001)

Turner, Silvie, *Facing the Page* (London: Estamp, 1993)

Turner Silvie, *The Book of Fine Paper* (London: Thames and Hudson, 1998)

GLOSSARY

Acetic acid A mild acid used for cleaning deposits left on intaglio plates when etched in ferric chloride.

Acetate A sheet of clear plastic used for registration when printing.

Aquatint An intaglio process whereby tone is achieved.

Artist's proof Part of an edition of prints that is set aside for use by the artist

Baren A Japanese burnishing pad traditionally covered in bamboo and used for printing relief prints by hand.

Beater A machine used in papermaking to process fibres or other raw material into pulp.

Bite Etching exposed areas of a metal plate using a corrosive agent.

Blotting paper An absorbent paper used for drying prints and also to draw out excess water from paper prior to printing.

Burnisher An oval metal tool with a rounded tip, used to smooth and polish metal in etching. For relief printing it can be any smooth tool used for hand-printing.

Carborundum Technical name: silicon carbide. Powdered, abrasive, sand-like grit, used to create tones on metal plates.

Chine collé A technique whereby collaged paper is placed glue side up onto an inked plate, which is then covered by the prepared printing paper and printed.

Collage A composition made of different pieces of paper adhered to single a surface.

Collagraph A print produced from an image with a raised surface made using different materials and glue.

Colophon A statement given at the end of a book, which includes author's details and book-production information.

Composite print A print produced from a number of different plates, blocks or stencils, or combinations of printmaking techniques.

Cotton rag This material comes from the fibres within cottonseed. It can also be recycled rag from cotton sheeting.

Couching The process of transferring freshly made paper sheets from the mould and deckle onto fabric to dry.

Counter-proofing Offsetting an image freshly printed onto tissue paper prior to reprinting it onto paper via an etching press.

Cross-hatching Parallel lines drawn next to and across each other to produce shadow and tone.

Dabber Leather-covered cotton pad used either to spread ink or to apply grounds to metal plates.

Deckle A wood frame that holds paper pulp to a screen while paper is

produced. The word also means a natural edge to a sheet of handmade or mould-made paper.

Digital print A print produced from a computer.

Drypoint Intaglio technique produced by scratching and scoring lines with pressure across a metal plate.

Dust bag or box Used to apply resin dust to a plate, producing tone.

Edition The number of prints taken from each plate or block.

Embossed print An intaglio print printed without ink under the heavy rolling pressure of an etching press.

End grain The side of a block of wood that does not show any grain, it is normally used in wood engraving.

Etching Intaglio technique whereby a metal plate is covered with an acid-resistant ground, and a subsequent drawing exposes the metal. The plate is placed in a solution of ferric chloride or acid, the etched areas are depressed or eaten, and the resulting marks are printed with ink.

Ferric chloride A corrosive used to etch metal plates.

Flood A term used in silkscreen whereby a squeegee is run across an inked screen prior to each print being taken, to stop the ink from drying in the mesh.

Foul biting Accidental pit marks that can occur while a metal plate is etching.

French chalk Powder produced from magnesium silicate, also called talcum powder or whiting.

Gelatin Glue-like substance used for size in paper.

Giclée Fine-art inkjet print

Gouge Tool used for wood- and linocutting.

Green etch or gum A solution containing tannic and phosphoric acids, it is used to process plate lithography.

Ground An acid-resistant substance used in etching to protect the plate when it is being bitten

Gum Arabic A natural gum produced from the acacia tree, predominantly used in lithography.

Hand-wiping A technique to remove excess ink by using the palm of the hand just prior to printing an etching.

Intaglio A printing process whereby the paper is forced into depressed lines which hold ink, and run through a press under a heavy rolling pressure. This technique includes etching and drypoint.

Linocut Linoleum used for relief printing

Lithography A chemical process using zinc or aluminium or limestone, relying on the fact that oil and water do not mix. As the image remains on the surface, this process can also be referred to as 'planography'.

Mesh A polyester material stretched over a wooden frame for screen-printing.

Monoprint A unique print.

Mould A wood frame, one side of which is covered with mesh to catch and hold the paper pulp to make the paper.

Muller A tool made of marble or glass with a roughened base, used to grind pigment mixed with oil to make ink.

Open bite This is where a wider area of exposed metal is etched.

Positive This is where the image is the printed area.

Proof A test print to see which areas need more work or to try out variations of technique and colour.

Pulp The main ingredient in papermaking.

Reduction method To produce a relief print using more than one colour but only one block.

Registration The adjustment of blocks, plates and screens to ensure the correct placement of different colours.

Relief print This process relies on a surface roll of ink. Anything that is cut does not print.

Resin A natural substance, available in lump or powder form, which melts when heated and gives tone to etching.

Scraper A sharp-pointed tool with three sides, used in etching to scrape away unwanted areas on an etched metal plate.

Scrim A heavily sized open-weave cotton fabric used to wipe an inked intaglio plate. Also called tarlatan.

Silkscreen A printing process that relies on a stencil technique. The stencil is used to block the ink from printing in unwanted areas. A stencil can be made of paper or produced by other techniques, sometimes photographic ones.

Size A gelatine substance that reduces the absorbency of paper.

Snap In silkscreen, there is an optimum distance between the screen and paper that allows for a clean print when the squeegee is pulled across the screen.

Squeegee A tool used in silkscreen, it has a rubber blade set within a wood or metal casing and is used to push the ink through a silkscreen mesh.

Stipple An etching drypoint technique using closely spaced dots to create tone.

Stop-out A solution such as varnish that acts in the same way as a ground in etching.

Suger lift A saturated sugar solution used in etching.

Surface roll Inking an image on a surface plane as opposed to a groove.

Tusche Grease-based drawing material, often liquid in form, used for drawing or painting in lithography. It contains wax, lard, soap, shellac, and lampblack pigment or soot.

Whiting *See* French chalk.

Wood-pulp paper Paper made with wood fibres.

INDEX